THE ALLEN BOOK OF
Painting and Drawing
HORSES

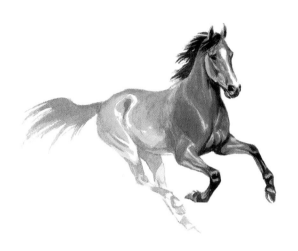

THE ALLEN BOOK OF
Painting and Drawing
HORSES

Jennifer Bell

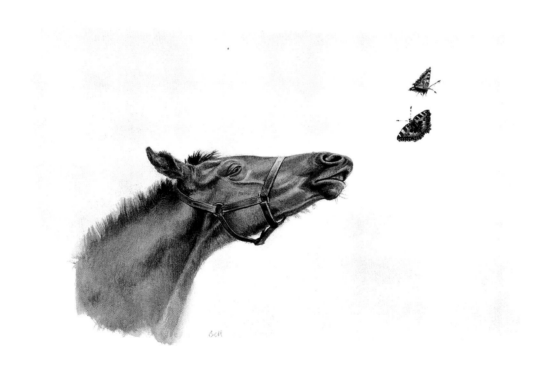

J. A. ALLEN · LONDON

Revised edition © Jenny Bell 2011
First published in Great Britain 2000
Reprinted 2000
Reprinted 2002
Reprinted 2004
Reprinted 2007

ISBN 978 0 85131 981 0

J. A. Allen
Clerkenwell House
Clerkenwell Green
London EC1R 0HT

J. A. Allen is an imprint of Robert Hale Ltd

www.allenbooks.co.uk

British Library Cataloguing in Publication Data
A catalogue record for this book is available from the British Library

Conceived and illustrated by Jennifer Bell
Design by Paul Saunders
Edited by Jane Lake

Printed by Craft Print International Ltd, Singapore

CONTENTS

1. INTRODUCTION

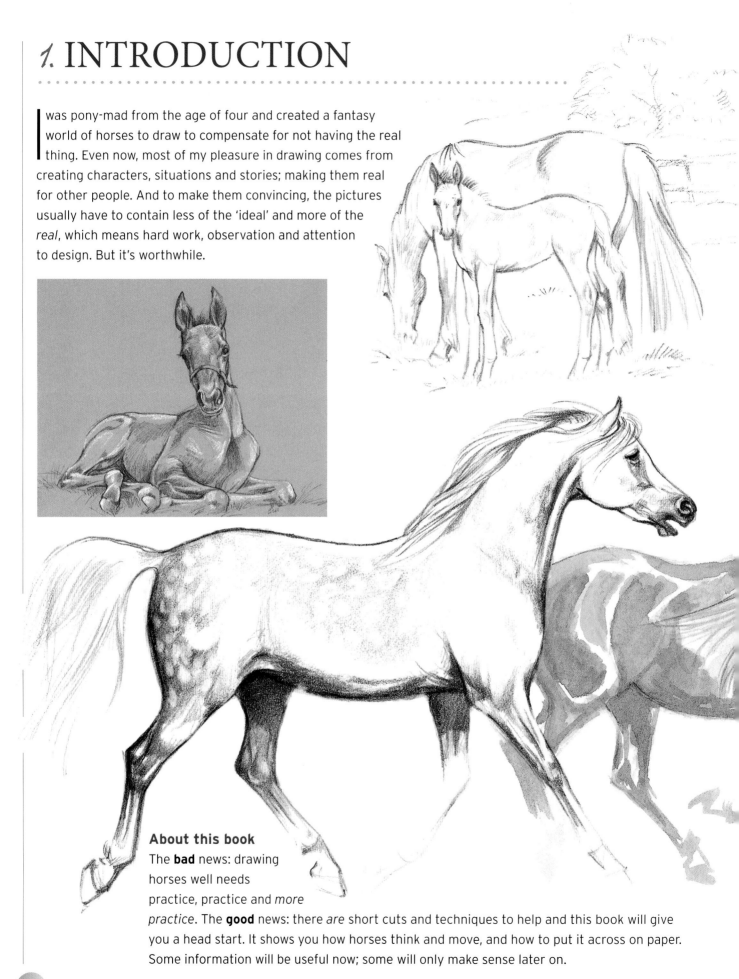

I was pony-mad from the age of four and created a fantasy world of horses to draw to compensate for not having the real thing. Even now, most of my pleasure in drawing comes from creating characters, situations and stories; making them real for other people. And to make them convincing, the pictures usually have to contain less of the 'ideal' and more of the *real*, which means hard work, observation and attention to design. But it's worthwhile.

About this book

The **bad** news: drawing horses well needs practice, practice and *more practice*. The **good** news: there *are* short cuts and techniques to help and this book will give you a head start. It shows you how horses think and move, and how to put it across on paper. Some information will be useful now; some will only make sense later on.

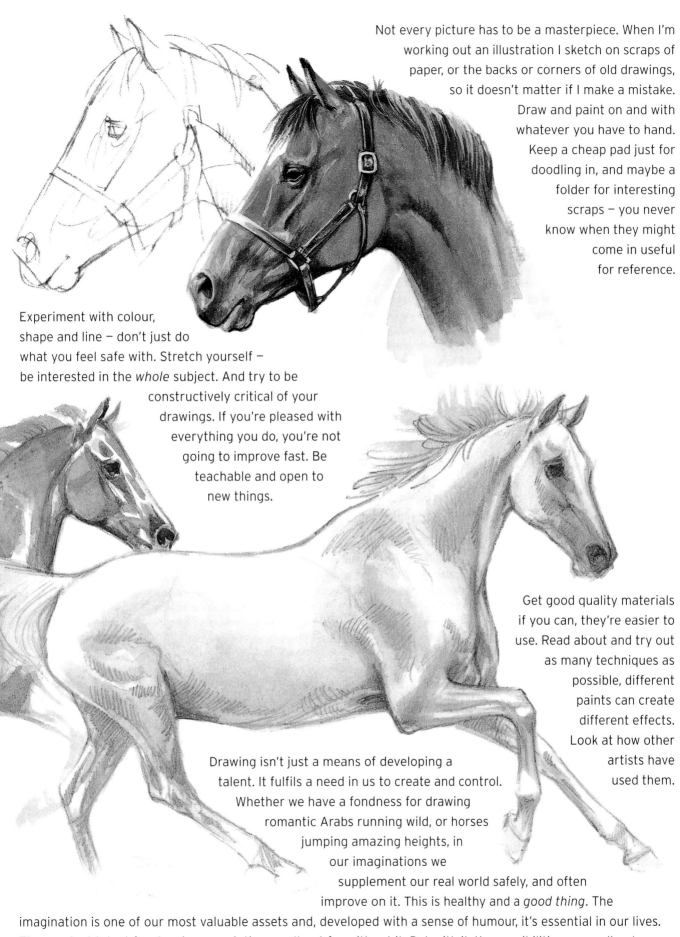

Not every picture has to be a masterpiece. When I'm working out an illustration I sketch on scraps of paper, or the backs or corners of old drawings, so it doesn't matter if I make a mistake. Draw and paint on and with whatever you have to hand. Keep a cheap pad just for doodling in, and maybe a folder for interesting scraps – you never know when they might come in useful for reference.

Experiment with colour, shape and line – don't just do what you feel safe with. Stretch yourself – be interested in the *whole* subject. And try to be constructively critical of your drawings. If you're pleased with everything you do, you're not going to improve fast. Be teachable and open to new things.

Get good quality materials if you can, they're easier to use. Read about and try out as many techniques as possible, different paints can create different effects. Look at how other artists have used them.

Drawing isn't just a means of developing a talent. It fulfils a need in us to create and control. Whether we have a fondness for drawing romantic Arabs running wild, or horses jumping amazing heights, in our imaginations we supplement our real world safely, and often improve on it. This is healthy and a *good thing*. The imagination is one of our most valuable assets and, developed with a sense of humour, it's essential in our lives. The greatest talent for drawing or painting won't get far without it. But *with it*, the possibilities are endless!

7

2. BASIC SHAPES

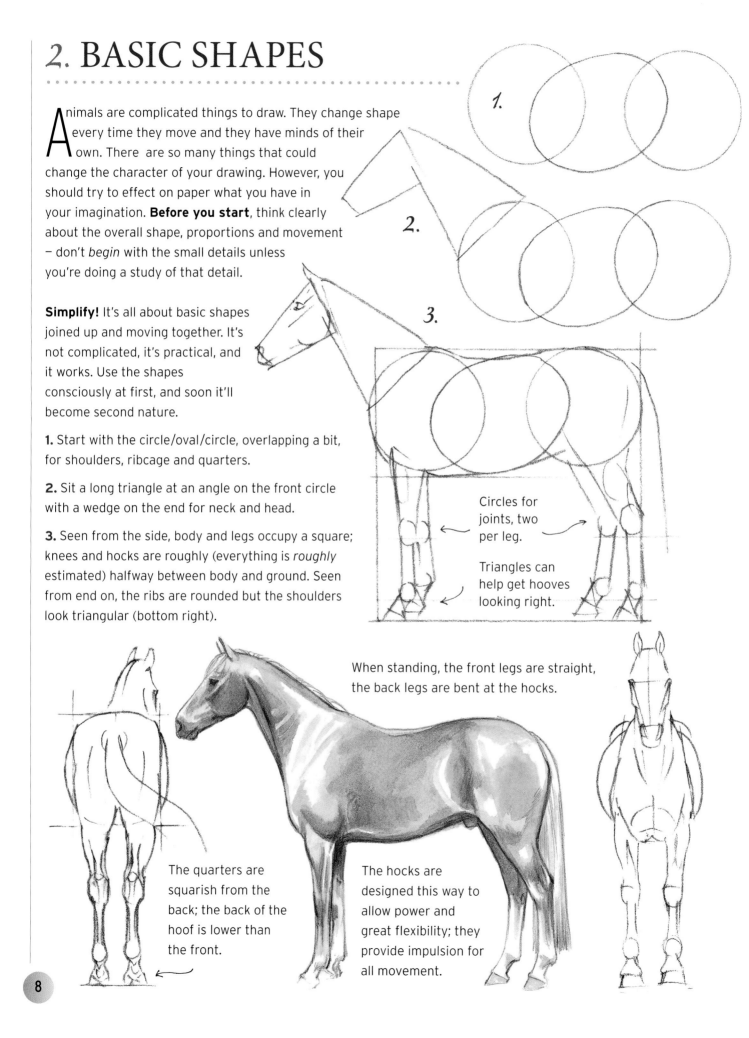

Animals are complicated things to draw. They change shape every time they move and they have minds of their own. There are so many things that could change the character of your drawing. However, you should try to effect on paper what you have in your imagination. **Before you start**, think clearly about the overall shape, proportions and movement – don't *begin* with the small details unless you're doing a study of that detail.

Simplify! It's all about basic shapes joined up and moving together. It's not complicated, it's practical, and it works. Use the shapes consciously at first, and soon it'll become second nature.

1. Start with the circle/oval/circle, overlapping a bit, for shoulders, ribcage and quarters.

2. Sit a long triangle at an angle on the front circle with a wedge on the end for neck and head.

3. Seen from the side, body and legs occupy a square; knees and hocks are roughly (everything is *roughly* estimated) halfway between body and ground. Seen from end on, the ribs are rounded but the shoulders look triangular (bottom right).

1.

2.

3.

Circles for joints, two per leg.

Triangles can help get hooves looking right.

When standing, the front legs are straight, the back legs are bent at the hocks.

The quarters are squarish from the back; the back of the hoof is lower than the front.

The hocks are designed this way to allow power and great flexibility; they provide impulsion for all movement.

Three similar circles have been used as the starting point for each of the drawings, but the different characters are determined by the varying proportions of legs and head to body, and the distinctive ways they move.

1. A typical riding or sport horse: well built, strong but athletic. **2.** A working horse: short, deep neck set low on powerful shoulders; squarish head; strong legs with big joints and feathering; short striding. **3.** Welsh mountain pony: short deep neck but set high; short strong legs with small hooves; well filled-out body; flowing mane and tail; short head with large cheekbone; extravagant leg action. **4.** Foal: thin, undeveloped legs, neck and body; big joints; tiny hooves; delicate head; irregular movements.

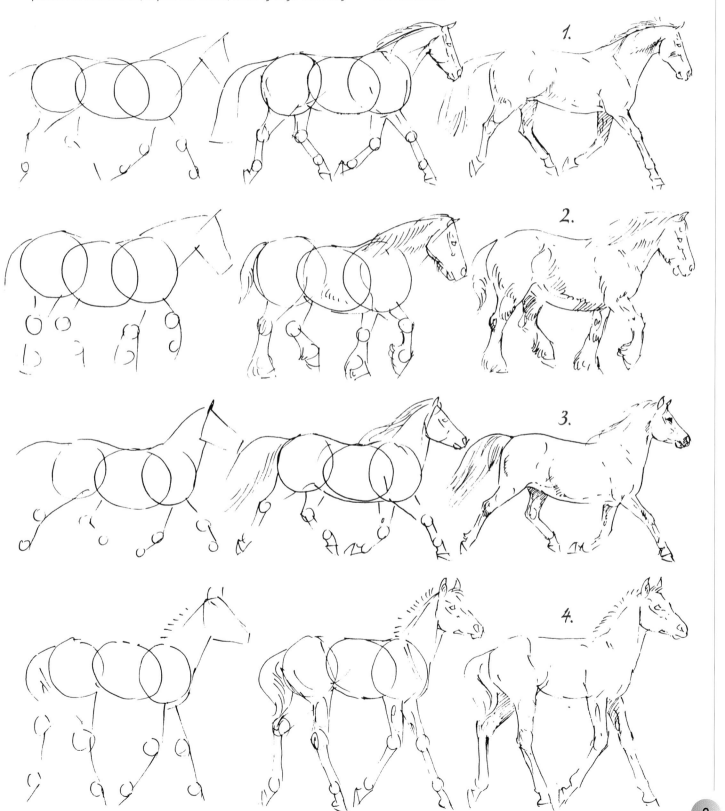

3. HEADS AND BODIES

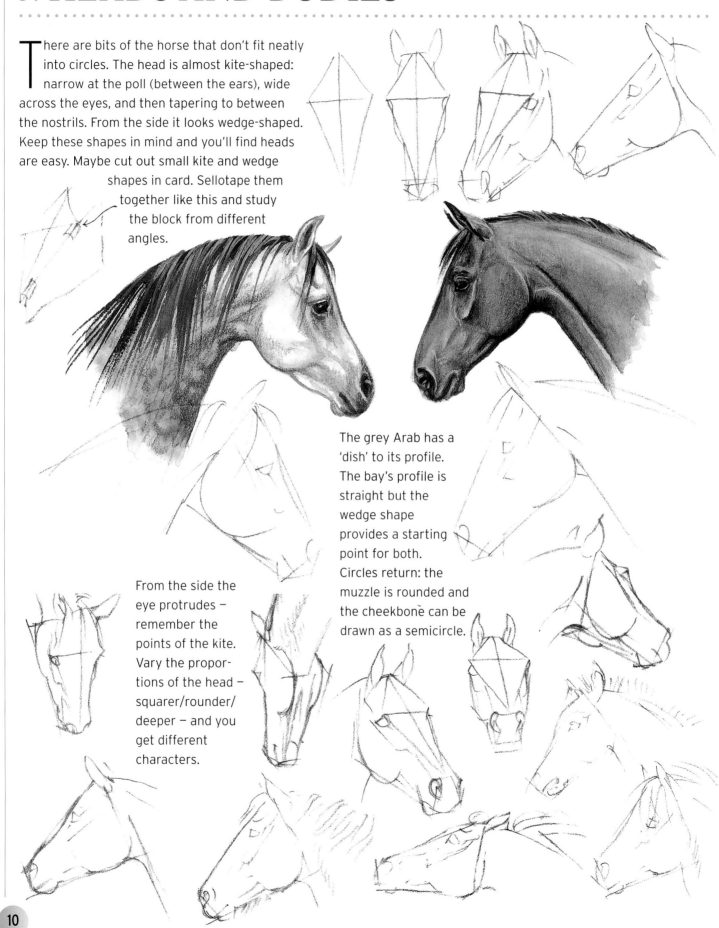

There are bits of the horse that don't fit neatly into circles. The head is almost kite-shaped: narrow at the poll (between the ears), wide across the eyes, and then tapering to between the nostrils. From the side it looks wedge-shaped. Keep these shapes in mind and you'll find heads are easy. Maybe cut out small kite and wedge shapes in card. Sellotape them together like this and study the block from different angles.

The grey Arab has a 'dish' to its profile. The bay's profile is straight but the wedge shape provides a starting point for both. Circles return: the muzzle is rounded and the cheekbone can be drawn as a semicircle.

From the side the eye protrudes – remember the points of the kite. Vary the propor-tions of the head – squarer/rounder/deeper – and you get different characters.

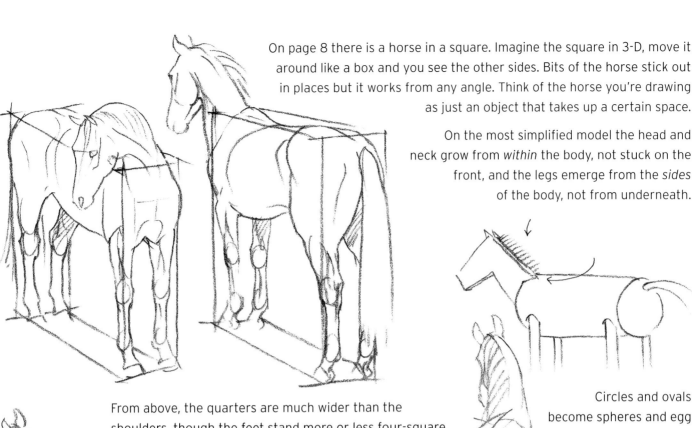

On page 8 there is a horse in a square. Imagine the square in 3-D, move it around like a box and you see the other sides. Bits of the horse stick out in places but it works from any angle. Think of the horse you're drawing as just an object that takes up a certain space.

On the most simplified model the head and neck grow from *within* the body, not stuck on the front, and the legs emerge from the *sides* of the body, not from underneath.

Circles and ovals become spheres and egg shapes. You don't need to draw boxes every time, but they can help with difficult bits of the drawing. For instance, here the body obscures much of the far foreleg, so to get the proportions right, it's handy to think of a dotted line across the chest to where the top of the other leg would start.

From above, the quarters are much wider than the shoulders, though the feet stand more or less four-square. The neck is thinner than you might imagine from the wideness of the side view.

Perspective means that an object seen in the distance will look smaller than when it's seen close up. The further away it is, the smaller it seems, till it vanishes. This is called the vanishing point! If you look at the 'boxes' above and right you'll see they get smaller going away from the viewer, you'll also see the horses drawn within the boxes conform to the box proportions, and seem to get smaller too...perspective made easy.

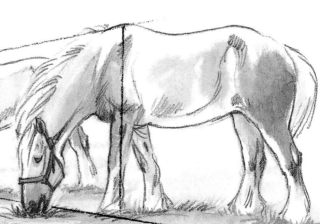

It's a rule that applies to *parts* of the object too. The horse's legs on the *far side* can be drawn very slightly shorter and thinner than the legs on the *nearside*.

Copying

Copying trains your eye to follow shape and line, and gives you the ability and confidence to draw freehand. It leaves plenty of room for personal expression but it can be inaccurate, most of us have a tendency to elongate shapes in one direction or another.

Details

Eyes Horses' eyes are designed to provide as much all-round vision as possible, so they are positioned partly to the side, partly to the front and seen fully only from the three-quarter view. From the side the eye seems to curve inwards. From the front the eye looks like an almond shape protruding slightly.

Remember, the eyeball is a sphere, mostly hidden by the eye-socket and shaded by eyelids. Unlike *our* eyes, the 'white' is rarely seen; the iris is large and dark, the eyelashes are long and usually the colour of the coat.

Tracing

Tracing is useful as a short cut. When I need to do an illustration *fast* I trace details to incorporate into the picture; it gives me the reality of the shape quickly, which my 'eye' might miss. But I don't rely on it. It would make me lazy.

Try an experiment

1. Copy a simple photograph. Try to get size, angles and proportion as correct as you can, reducing the shapes to basics first.

2. Trace the same photo and superimpose this over your copy. There will be differences!

3. Then try another freehand copy, bearing in mind the shapes and angles you see in the tracing. This will be much more accurate than your first attempt.

Get the shape looking right first and your painting will be much more convincing.

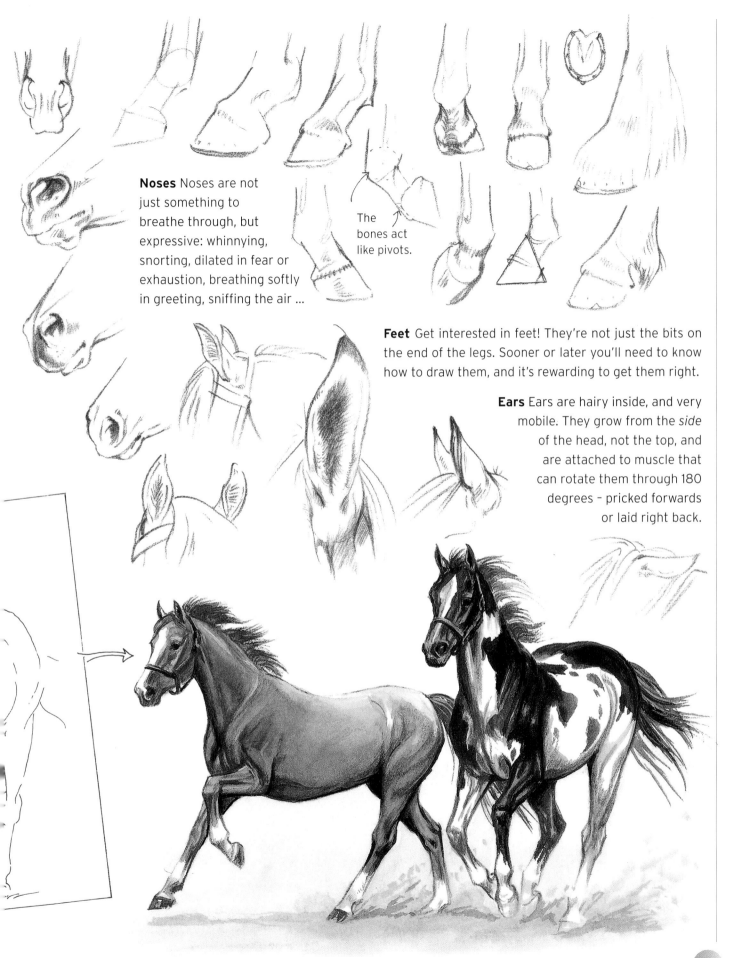

Noses Noses are not just something to breathe through, but expressive: whinnying, snorting, dilated in fear or exhaustion, breathing softly in greeting, sniffing the air ...

The bones act like pivots.

Feet Get interested in feet! They're not just the bits on the end of the legs. Sooner or later you'll need to know how to draw them, and it's rewarding to get them right.

Ears Ears are hairy inside, and very mobile. They grow from the *side* of the head, not the top, and are attached to muscle that can rotate them through 180 degrees – pricked forwards or laid right back.

5. MOVEMENT

Drawing movement

Sketch in, very roughly, the basic shapes: circles for the body, lines to indicate leg and neck direction. Join them up, add leg joints and head shape, but not necessarily in that order! You might like to take the line of the neck and back as your starting point. Don't go in for any detail yet. Develop a feel for the way horses move.

Walk is a four-time gait. There are four hoof-falls. The front foot is followed by the diagonal hind, the other front, and then the other hind.

Trot is two-time. Diagonal pairs of legs move together.

Canter is in three-time. The hind leg is followed by the other hind and its diagonal front leg together, and then the other front.

Gallop is in four-time, with an airborne moment ('period of suspension') in the middle.

If you're confused, get down on all fours and try it out for yourself!

Don't be nervous about drawing horses from strange angles. Imagine the basic spheres-and-egg shapes moving together and overlapping.

Sketch in the basic shape, direction of movement with circles and lines.

Block in, join up, indicate muscle, bone, tail etc.

14

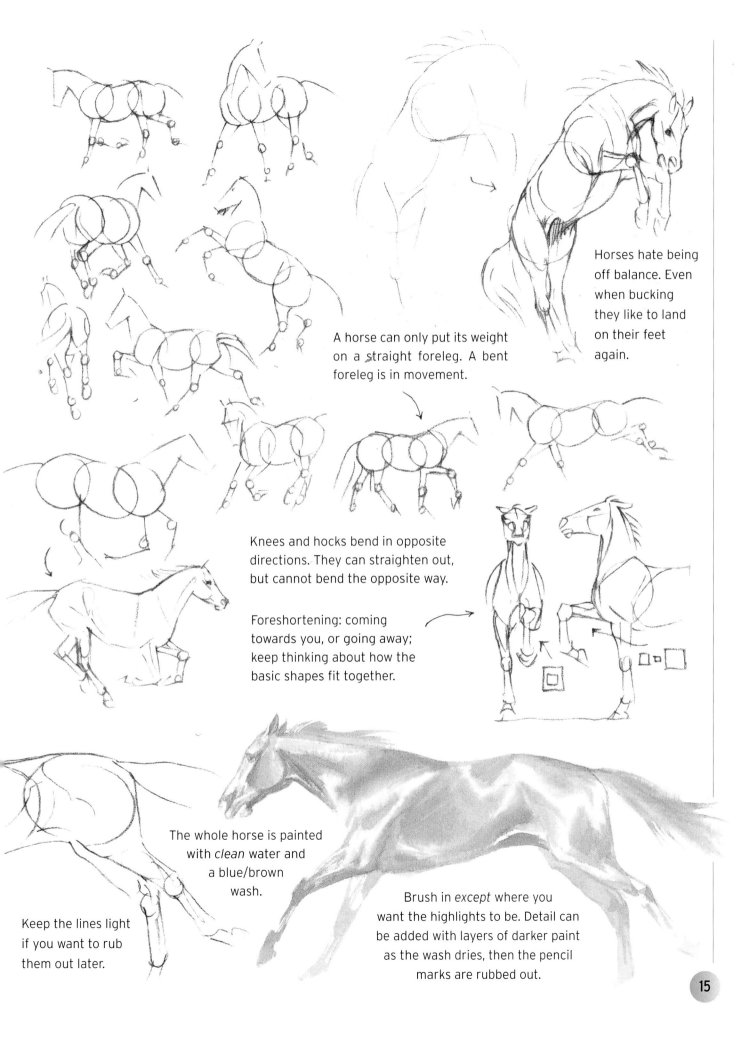

Horses hate being off balance. Even when bucking they like to land on their feet again.

A horse can only put its weight on a straight foreleg. A bent foreleg is in movement.

Knees and hocks bend in opposite directions. They can straighten out, but cannot bend the opposite way.

Foreshortening: coming towards you, or going away; keep thinking about how the basic shapes fit together.

The whole horse is painted with *clean* water and a blue/brown wash.

Keep the lines light if you want to rub them out later.

Brush in *except* where you want the highlights to be. Detail can be added with layers of darker paint as the wash dries, then the pencil marks are rubbed out.

6. BASIC STRUCTURES

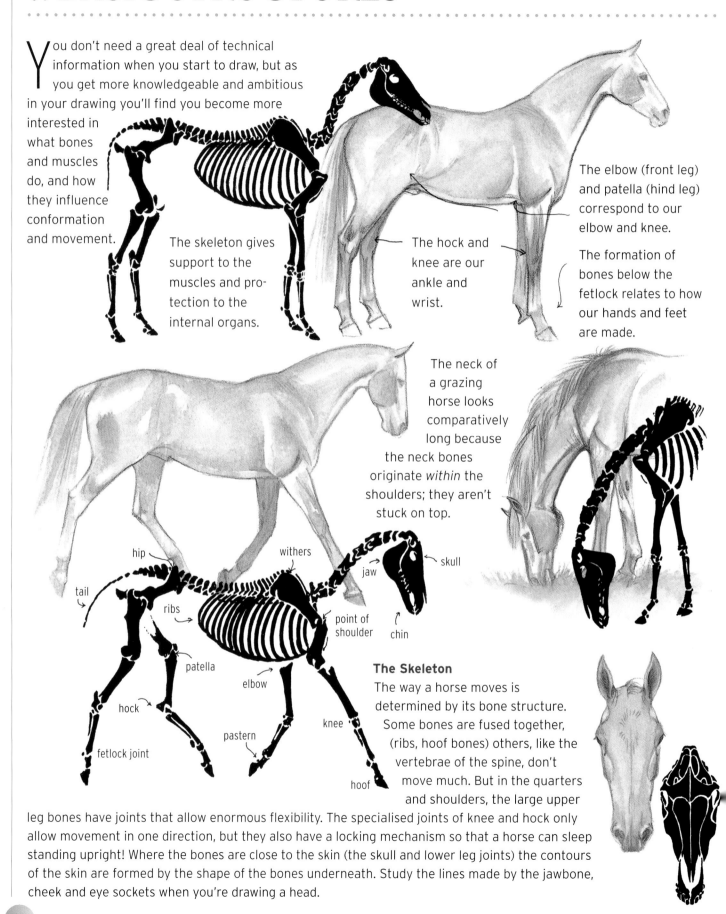

You don't need a great deal of technical information when you start to draw, but as you get more knowledgeable and ambitious in your drawing you'll find you become more interested in what bones and muscles do, and how they influence conformation and movement.

The skeleton gives support to the muscles and protection to the internal organs.

The hock and knee are our ankle and wrist.

The elbow (front leg) and patella (hind leg) correspond to our elbow and knee.

The formation of bones below the fetlock relates to how our hands and feet are made.

The neck of a grazing horse looks comparatively long because the neck bones originate *within* the shoulders; they aren't stuck on top.

hip
withers
skull
jaw
tail
ribs
point of shoulder
chin
patella
elbow
hock
knee
pastern
fetlock joint
hoof

The Skeleton
The way a horse moves is determined by its bone structure. Some bones are fused together, (ribs, hoof bones) others, like the vertebrae of the spine, don't move much. But in the quarters and shoulders, the large upper leg bones have joints that allow enormous flexibility. The specialised joints of knee and hock only allow movement in one direction, but they also have a locking mechanism so that a horse can sleep standing upright! Where the bones are close to the skin (the skull and lower leg joints) the contours of the skin are formed by the shape of the bones underneath. Study the lines made by the jawbone, cheek and eye sockets when you're drawing a head.

16

Compare this horse with the skeleton (opposite) and the illustration of the muscle structure (below) and you can see where bones, muscle or tendons are indicated.

Muscles

Immediately under the skin are the surface muscles. The slightest movement the horse makes (even twitching or blinking) will involve the use of a number of muscles, some tightening up, others giving.

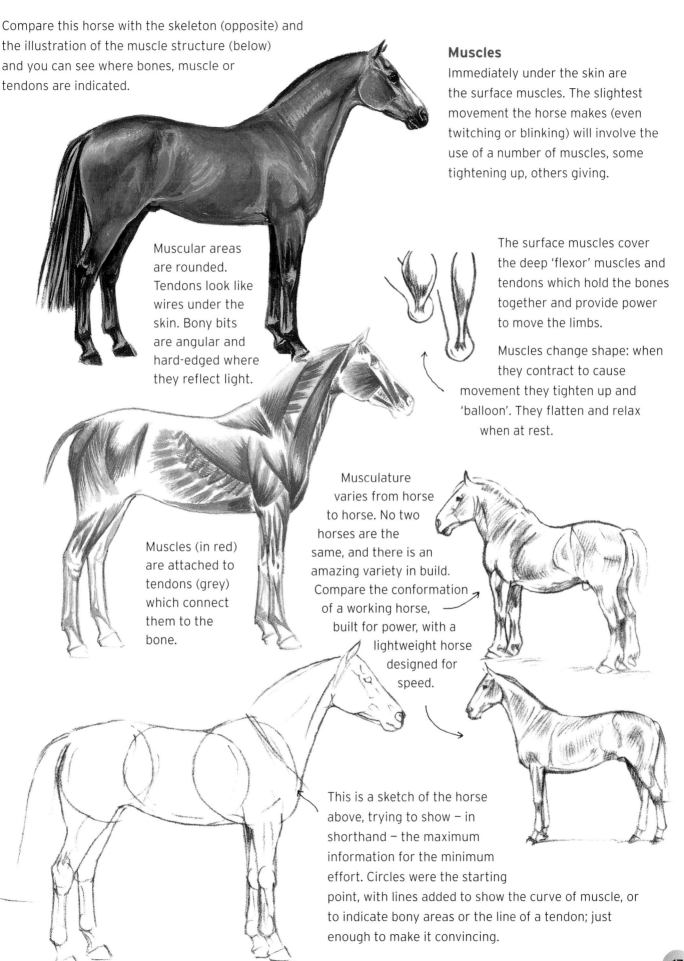

Muscular areas are rounded. Tendons look like wires under the skin. Bony bits are angular and hard-edged where they reflect light.

The surface muscles cover the deep 'flexor' muscles and tendons which hold the bones together and provide power to move the limbs.

Muscles change shape: when they contract to cause movement they tighten up and 'balloon'. They flatten and relax when at rest.

Muscles (in red) are attached to tendons (grey) which connect them to the bone.

Musculature varies from horse to horse. No two horses are the same, and there is an amazing variety in build. Compare the conformation of a working horse, built for power, with a lightweight horse designed for speed.

This is a sketch of the horse above, trying to show – in shorthand – the maximum information for the minimum effort. Circles were the starting point, with lines added to show the curve of muscle, or to indicate bony areas or the line of a tendon; just enough to make it convincing.

7. BLACK, WHITE AND COLOUR

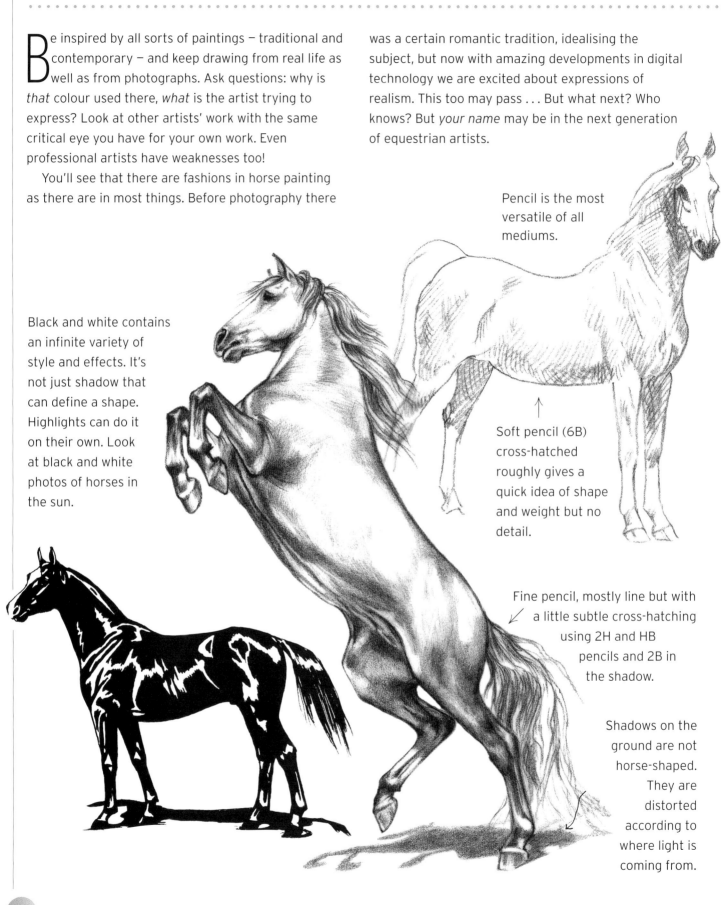

Be inspired by all sorts of paintings – traditional and contemporary – and keep drawing from real life as well as from photographs. Ask questions: why is *that* colour used there, *what* is the artist trying to express? Look at other artists' work with the same critical eye you have for your own work. Even professional artists have weaknesses too!

You'll see that there are fashions in horse painting as there are in most things. Before photography there was a certain romantic tradition, idealising the subject, but now with amazing developments in digital technology we are excited about expressions of realism. This too may pass . . . But what next? Who knows? But *your name* may be in the next generation of equestrian artists.

Pencil is the most versatile of all mediums.

Black and white contains an infinite variety of style and effects. It's not just shadow that can define a shape. Highlights can do it on their own. Look at black and white photos of horses in the sun.

Soft pencil (6B) cross-hatched roughly gives a quick idea of shape and weight but no detail.

Fine pencil, mostly line but with a little subtle cross-hatching using 2H and HB pencils and 2B in the shadow.

Shadows on the ground are not horse-shaped. They are distorted according to where light is coming from.

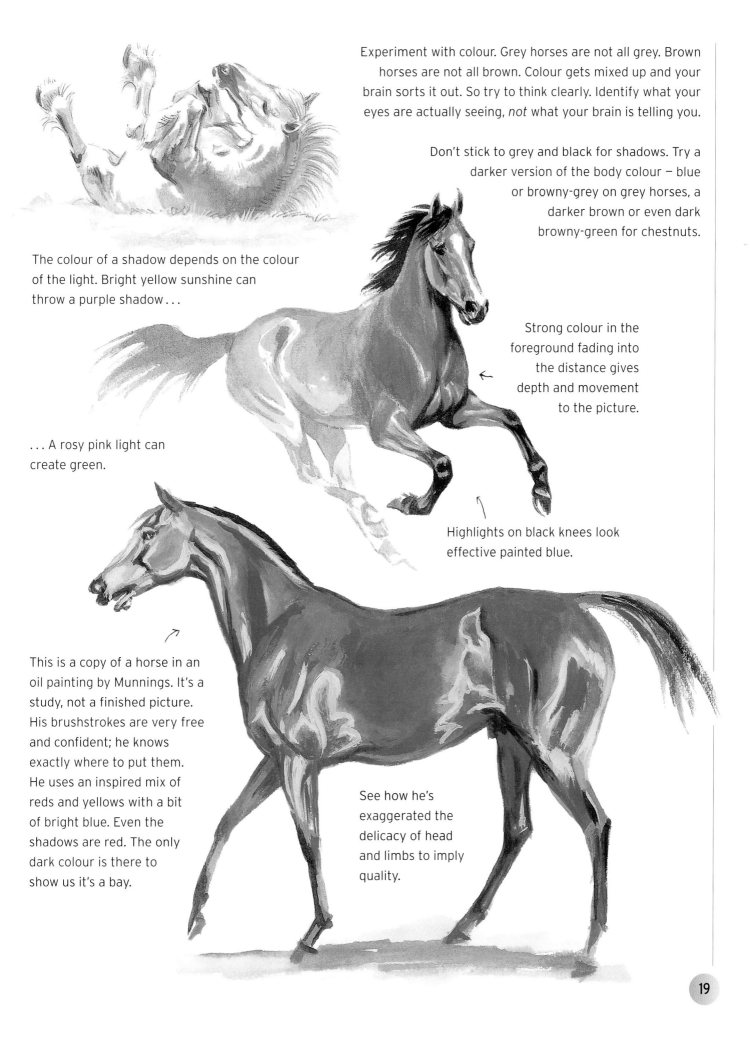

Experiment with colour. Grey horses are not all grey. Brown horses are not all brown. Colour gets mixed up and your brain sorts it out. So try to think clearly. Identify what your eyes are actually seeing, *not* what your brain is telling you.

Don't stick to grey and black for shadows. Try a darker version of the body colour – blue or browny-grey on grey horses, a darker brown or even dark browny-green for chestnuts.

The colour of a shadow depends on the colour of the light. Bright yellow sunshine can throw a purple shadow...

Strong colour in the foreground fading into the distance gives depth and movement to the picture.

...A rosy pink light can create green.

Highlights on black knees look effective painted blue.

This is a copy of a horse in an oil painting by Munnings. It's a study, not a finished picture. His brushstrokes are very free and confident; he knows exactly where to put them. He uses an inspired mix of reds and yellows with a bit of bright blue. Even the shadows are red. The only dark colour is there to show us it's a bay.

See how he's exaggerated the delicacy of head and limbs to imply quality.

19

8. ANCESTRAL HORSES

Eohippus – the 'Dawn Horse' – was the size of a dog and lived in forest undergrowth. Over millions of years it moved into the savannah, its teeth now adapted to grazing, and its toes fused together. Cased in horn, the hoof evolved to bear the wild horse's increased weight, and enabled it to depend on speed to escape from predators in the open grasslands.

The only truly 'wild' horse today is the Asian Przewalski's Horse, and it bears a striking similarity to horses in prehistoric cave paintings.

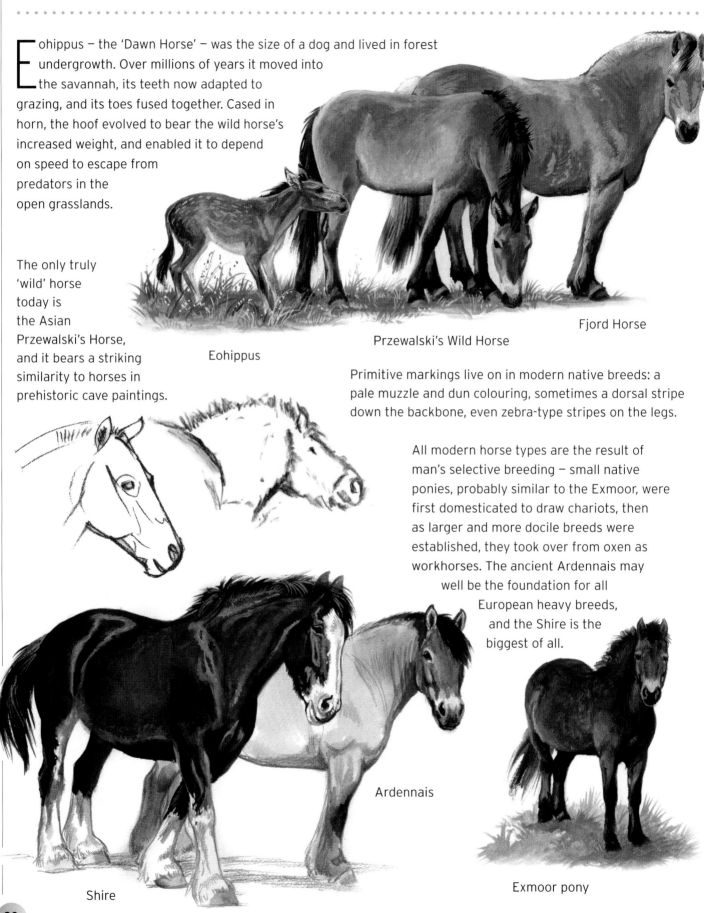

Eohippus

Przewalski's Wild Horse

Fjord Horse

Primitive markings live on in modern native breeds: a pale muzzle and dun colouring, sometimes a dorsal stripe down the backbone, even zebra-type stripes on the legs.

All modern horse types are the result of man's selective breeding – small native ponies, probably similar to the Exmoor, were first domesticated to draw chariots, then as larger and more docile breeds were established, they took over from oxen as workhorses. The ancient Ardennais may well be the foundation for all European heavy breeds, and the Shire is the biggest of all.

Ardennais

Shire

Exmoor pony

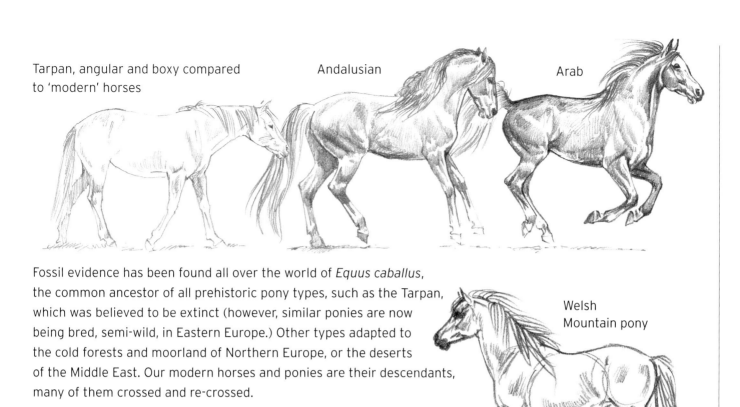

Tarpan, angular and boxy compared to 'modern' horses

Andalusian

Arab

Welsh Mountain pony

Fossil evidence has been found all over the world of *Equus caballus*, the common ancestor of all prehistoric pony types, such as the Tarpan, which was believed to be extinct (however, similar ponies are now being bred, semi-wild, in Eastern Europe.) Other types adapted to the cold forests and moorland of Northern Europe, or the deserts of the Middle East. Our modern horses and ponies are their descendants, many of them crossed and re-crossed.

The Arab is one of the purest breeds, tracing its ancestry back 5,000 years. Fast and intelligent, it was a status symbol and revered for its beauty and stamina. Crossed with quality native ponies during the Moorish occupation of Spain, it produced the Andalusian, famed for its graceful action, quiet temperament and trainability for war. The skills developed for medieval warfare are the basis of the disciplines of *Haute Ecole*.

Arab and Spanish blood, first introduced by the Romans, is also evident in modern native ponies like the Welsh and the Highland.

The donkey, a descendant of the wild desert ass, was domesticated long before its distant cousin, the wild horse. Mating a jackass and a mare produces a mule, which in ancient times was the favoured mount of kings.

The African Zebra is also of the horse family, but has never been truly domesticated.

Highland pony

Mule

Zebra

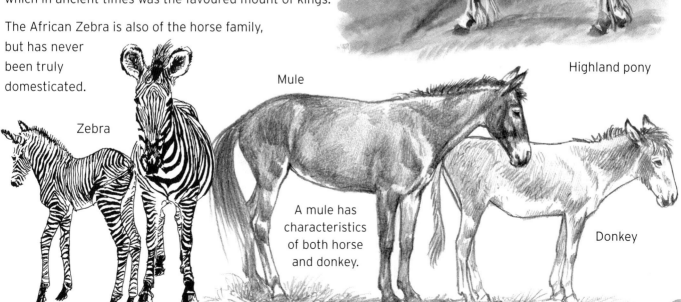

A mule has characteristics of both horse and donkey.

Donkey

9. BREEDING

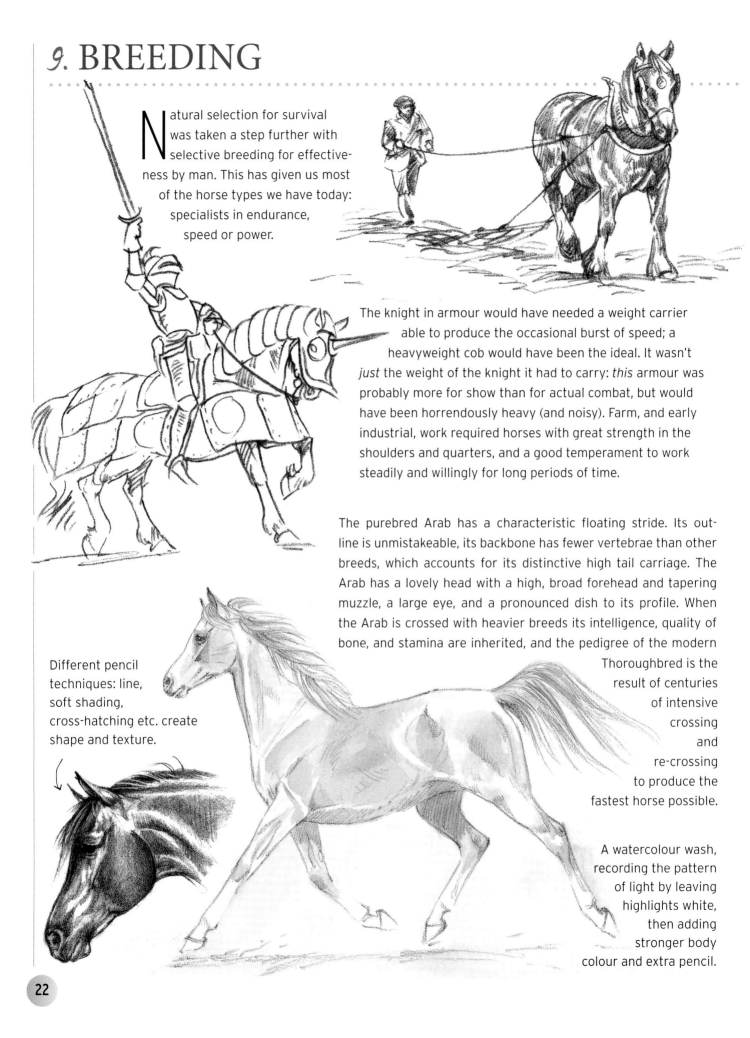

Natural selection for survival was taken a step further with selective breeding for effectiveness by man. This has given us most of the horse types we have today: specialists in endurance, speed or power.

The knight in armour would have needed a weight carrier able to produce the occasional burst of speed; a heavyweight cob would have been the ideal. It wasn't *just* the weight of the knight it had to carry: *this* armour was probably more for show than for actual combat, but would have been horrendously heavy (and noisy). Farm, and early industrial, work required horses with great strength in the shoulders and quarters, and a good temperament to work steadily and willingly for long periods of time.

The purebred Arab has a characteristic floating stride. Its outline is unmistakeable, its backbone has fewer vertebrae than other breeds, which accounts for its distinctive high tail carriage. The Arab has a lovely head with a high, broad forehead and tapering muzzle, a large eye, and a pronounced dish to its profile. When the Arab is crossed with heavier breeds its intelligence, quality of bone, and stamina are inherited, and the pedigree of the modern Thoroughbred is the result of centuries of intensive crossing and re-crossing to produce the fastest horse possible.

Different pencil techniques: line, soft shading, cross-hatching etc. create shape and texture.

A watercolour wash, recording the pattern of light by leaving highlights white, then adding stronger body colour and extra pencil.

22

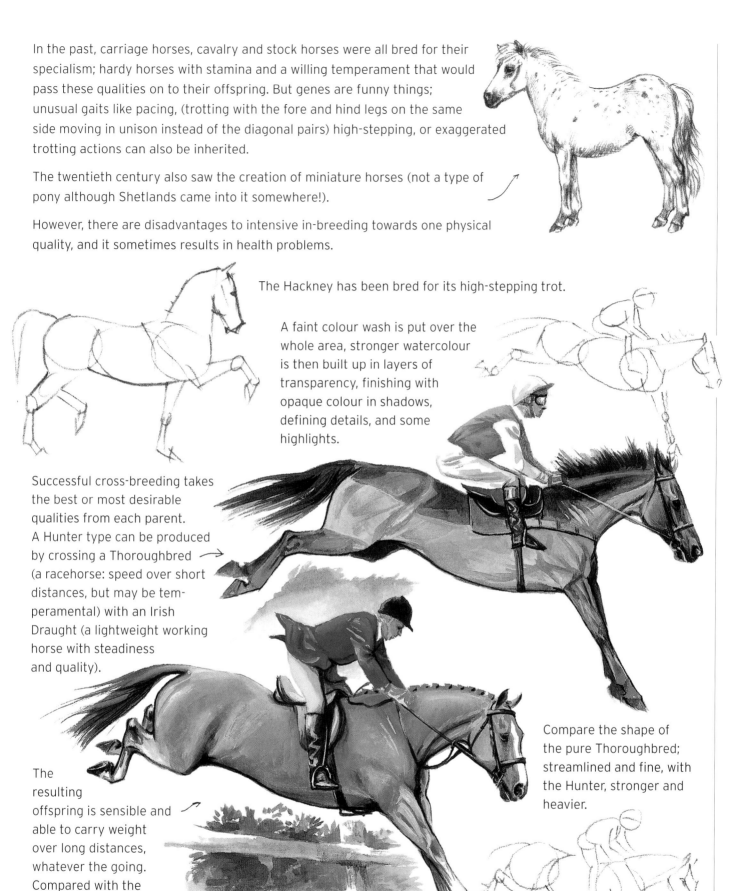

In the past, carriage horses, cavalry and stock horses were all bred for their specialism; hardy horses with stamina and a willing temperament that would pass these qualities on to their offspring. But genes are funny things; unusual gaits like pacing, (trotting with the fore and hind legs on the same side moving in unison instead of the diagonal pairs) high-stepping, or exaggerated trotting actions can also be inherited.

The twentieth century also saw the creation of miniature horses (not a type of pony although Shetlands came into it somewhere!).

However, there are disadvantages to intensive in-breeding towards one physical quality, and it sometimes results in health problems.

The Hackney has been bred for its high-stepping trot.

A faint colour wash is put over the whole area, stronger watercolour is then built up in layers of transparency, finishing with opaque colour in shadows, defining details, and some highlights.

Successful cross-breeding takes the best or most desirable qualities from each parent. A Hunter type can be produced by crossing a Thoroughbred (a racehorse: speed over short distances, but may be temperamental) with an Irish Draught (a lightweight working horse with steadiness and quality).

The resulting offspring is sensible and able to carry weight over long distances, whatever the going. Compared with the pure Thoroughbred it is slower, not so excitable, but it is still athletic and jumps well.

Compare the shape of the pure Thoroughbred; streamlined and fine, with the Hunter, stronger and heavier.

23

10. THE HERD

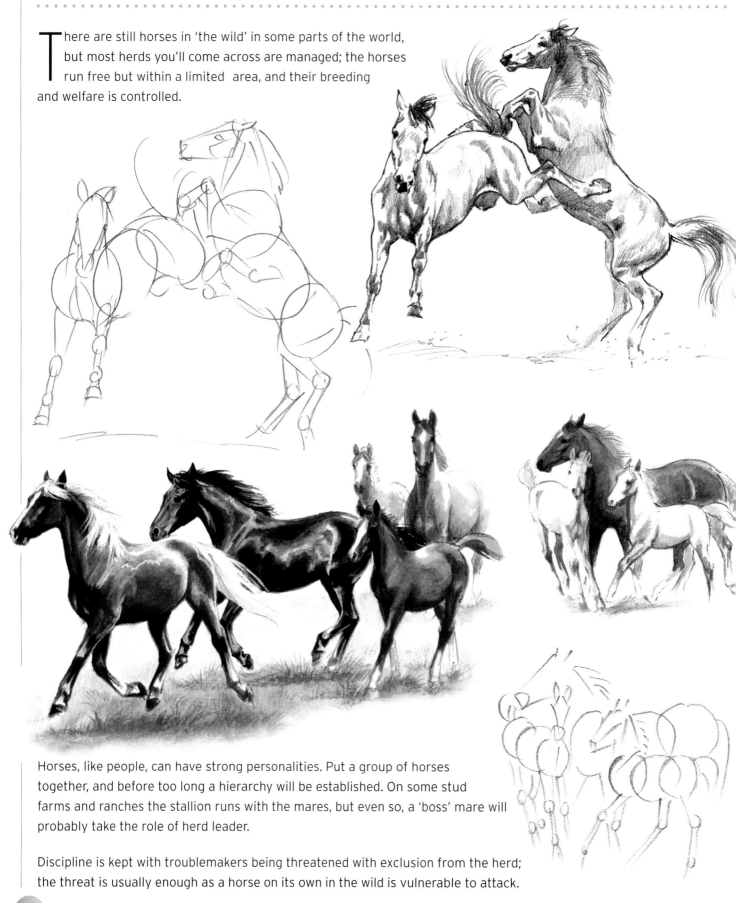

There are still horses in 'the wild' in some parts of the world, but most herds you'll come across are managed; the horses run free but within a limited area, and their breeding and welfare is controlled.

Horses, like people, can have strong personalities. Put a group of horses together, and before too long a hierarchy will be established. On some stud farms and ranches the stallion runs with the mares, but even so, a 'boss' mare will probably take the role of herd leader.

Discipline is kept with troublemakers being threatened with exclusion from the herd; the threat is usually enough as a horse on its own in the wild is vulnerable to attack.

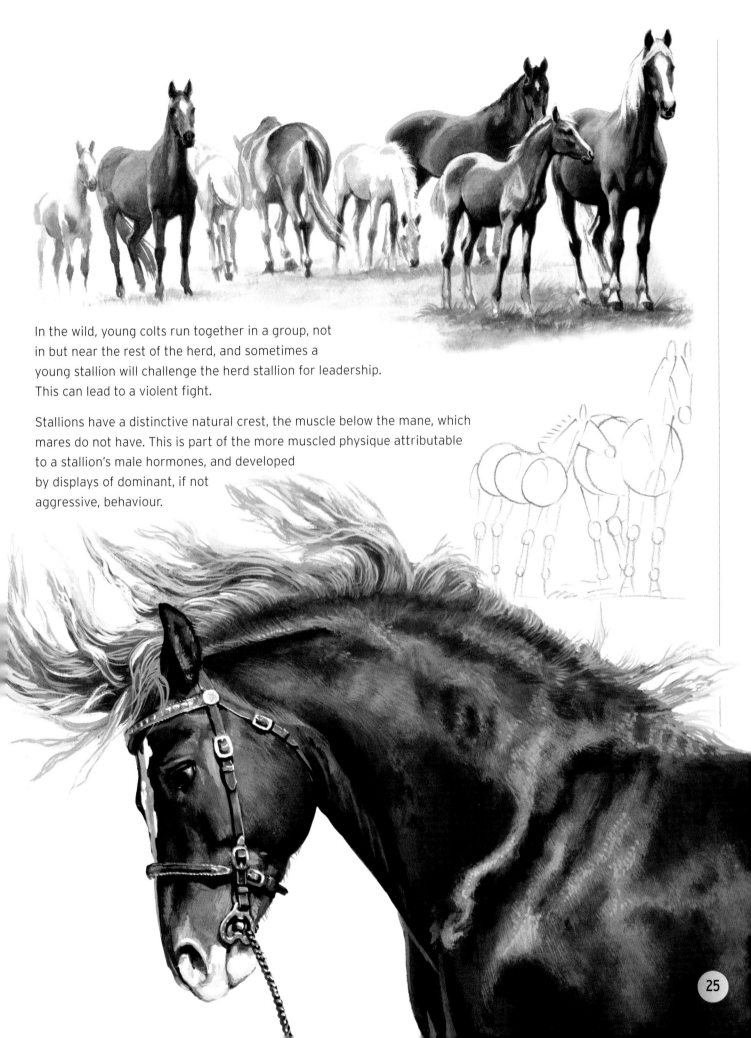

In the wild, young colts run together in a group, not in but near the rest of the herd, and sometimes a young stallion will challenge the herd stallion for leadership. This can lead to a violent fight.

Stallions have a distinctive natural crest, the muscle below the mane, which mares do not have. This is part of the more muscled physique attributable to a stallion's male hormones, and developed by displays of dominant, if not aggressive, behaviour.

11. FOALS

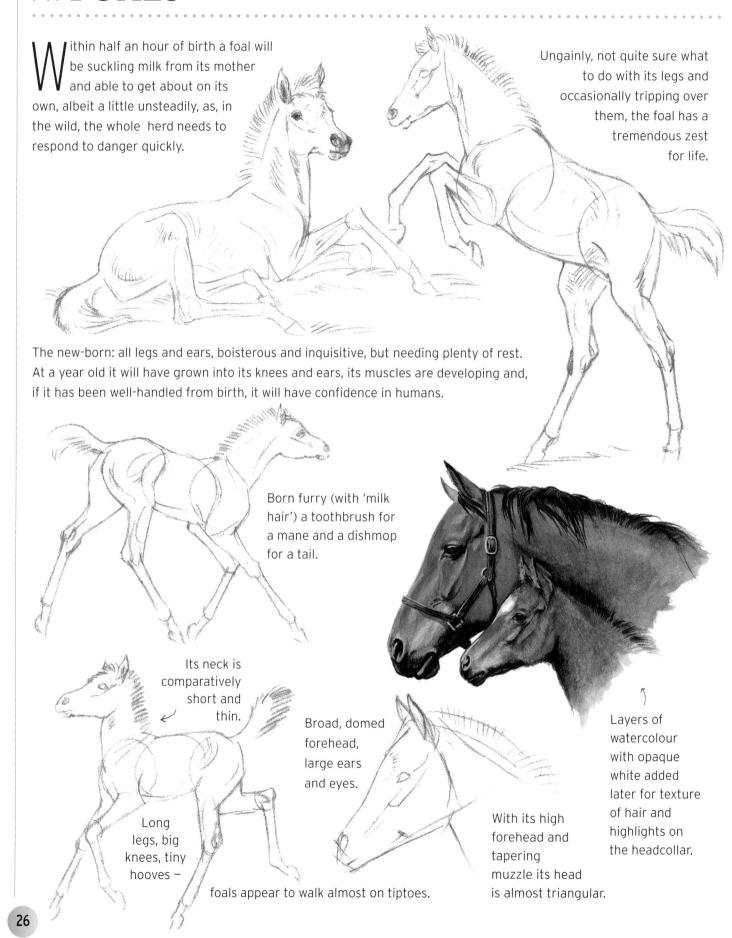

Within half an hour of birth a foal will be suckling milk from its mother and able to get about on its own, albeit a little unsteadily, as, in the wild, the whole herd needs to respond to danger quickly.

Ungainly, not quite sure what to do with its legs and occasionally tripping over them, the foal has a tremendous zest for life.

The new-born: all legs and ears, boisterous and inquisitive, but needing plenty of rest. At a year old it will have grown into its knees and ears, its muscles are developing and, if it has been well-handled from birth, it will have confidence in humans.

Born furry (with 'milk hair') a toothbrush for a mane and a dishmop for a tail.

Its neck is comparatively short and thin.

Broad, domed forehead, large ears and eyes.

Layers of watercolour with opaque white added later for texture of hair and highlights on the headcollar.

Long legs, big knees, tiny hooves –

foals appear to walk almost on tiptoes.

With its high forehead and tapering muzzle its head is almost triangular.

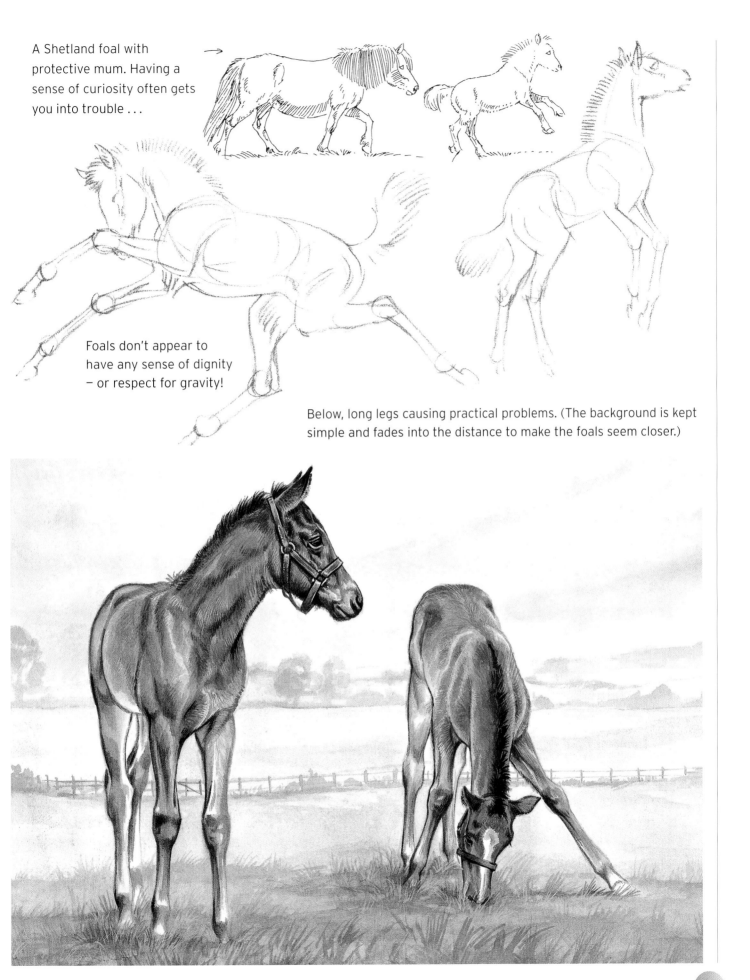

A Shetland foal with protective mum. Having a sense of curiosity often gets you into trouble ...

Foals don't appear to have any sense of dignity – or respect for gravity!

Below, long legs causing practical problems. (The background is kept simple and fades into the distance to make the foals seem closer.)

12. RIDERS

The best riders look as if they are part of the horse. They are not static and stiff and perched on top. Draw them as simply another set of shapes which moves with the movements of the horse. When you can draw riders riding correctly then you can have fun drawing people getting it wrong!

The basic shapes of the rider's body: head, chest, hips, are the circle/oval/circle again.

Legs are long wedge shapes with a small circle for the knee. The arms too, pivoting from the shoulder and bending at the elbow.

Think of feet as small triangles.

Even if you don't ride yourself, it's good to know how (and why) it's done. Then can you create convincing pictures.

Imagine yourself in the rider's position. What does it feel like to sit on a fat pony, rise to the trot, turn corners, move with the canter, or control a fast pony?

Children have different proportions from adults. Their heads are larger and legs shorter. During the teens arms and legs grow disproportionately long, and then the body starts to catch up and fill out.

Remember when you draw legs they are bent **out** and **around** the pony. They do not go straight down. This makes them look shorter from the side.

NB. Hats are larger than heads!

Riders come in all sorts of shapes and sizes, just like their horses.

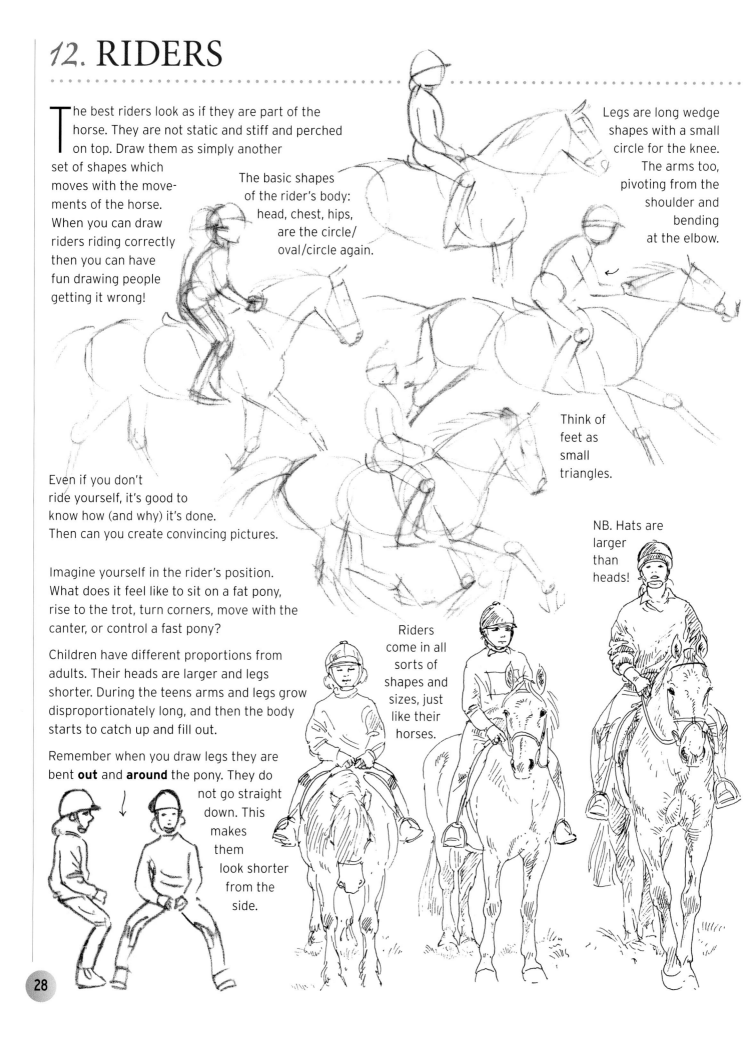

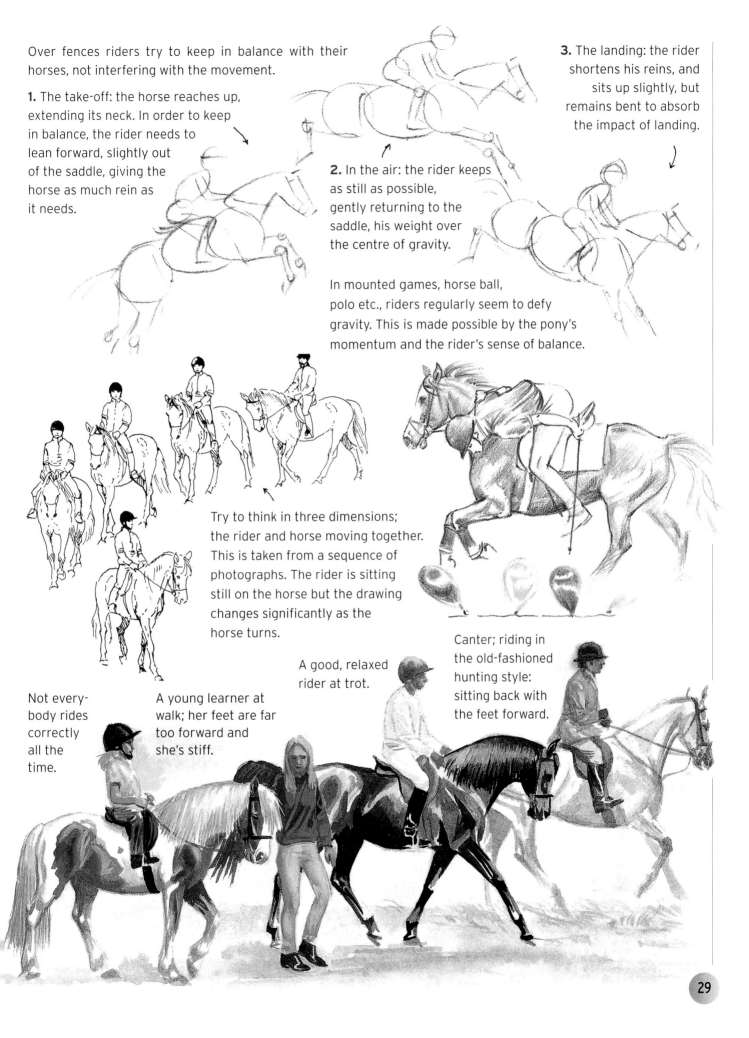

Over fences riders try to keep in balance with their horses, not interfering with the movement.

1. The take-off: the horse reaches up, extending its neck. In order to keep in balance, the rider needs to lean forward, slightly out of the saddle, giving the horse as much rein as it needs.

2. In the air: the rider keeps as still as possible, gently returning to the saddle, his weight over the centre of gravity.

3. The landing: the rider shortens his reins, and sits up slightly, but remains bent to absorb the impact of landing.

In mounted games, horse ball, polo etc., riders regularly seem to defy gravity. This is made possible by the pony's momentum and the rider's sense of balance.

Try to think in three dimensions; the rider and horse moving together. This is taken from a sequence of photographs. The rider is sitting still on the horse but the drawing changes significantly as the horse turns.

A good, relaxed rider at trot.

Canter; riding in the old-fashioned hunting style: sitting back with the feet forward.

Not everybody rides correctly all the time.

A young learner at walk; her feet are far too forward and she's stiff.

29

13. TACK

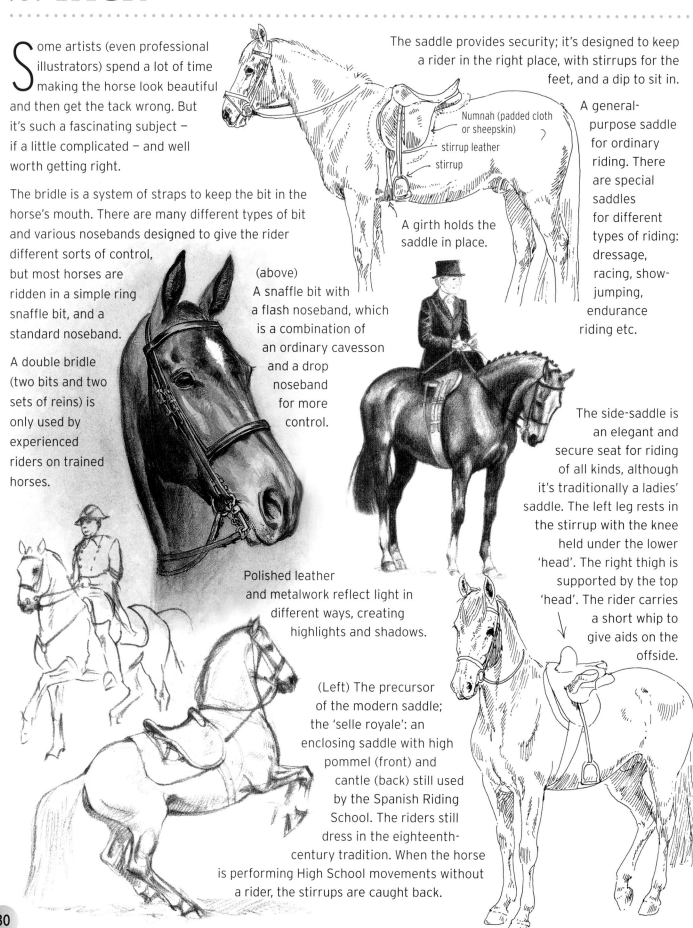

Some artists (even professional illustrators) spend a lot of time making the horse look beautiful and then get the tack wrong. But it's such a fascinating subject – if a little complicated – and well worth getting right.

The bridle is a system of straps to keep the bit in the horse's mouth. There are many different types of bit and various nosebands designed to give the rider different sorts of control, but most horses are ridden in a simple ring snaffle bit, and a standard noseband.

A double bridle (two bits and two sets of reins) is only used by experienced riders on trained horses.

The saddle provides security; it's designed to keep a rider in the right place, with stirrups for the feet, and a dip to sit in.

Numnah (padded cloth or sheepskin)

stirrup leather

stirrup

A girth holds the saddle in place.

A general-purpose saddle for ordinary riding. There are special saddles for different types of riding: dressage, racing, show-jumping, endurance riding etc.

(above)
A snaffle bit with a flash noseband, which is a combination of an ordinary cavesson and a drop noseband for more control.

Polished leather and metalwork reflect light in different ways, creating highlights and shadows.

The side-saddle is an elegant and secure seat for riding of all kinds, although it's traditionally a ladies' saddle. The left leg rests in the stirrup with the knee held under the lower 'head'. The right thigh is supported by the top 'head'. The rider carries a short whip to give aids on the offside.

(Left) The precursor of the modern saddle; the 'selle royale': an enclosing saddle with high pommel (front) and cantle (back) still used by the Spanish Riding School. The riders still dress in the eighteenth-century tradition. When the horse is performing High School movements without a rider, the stirrups are caught back.

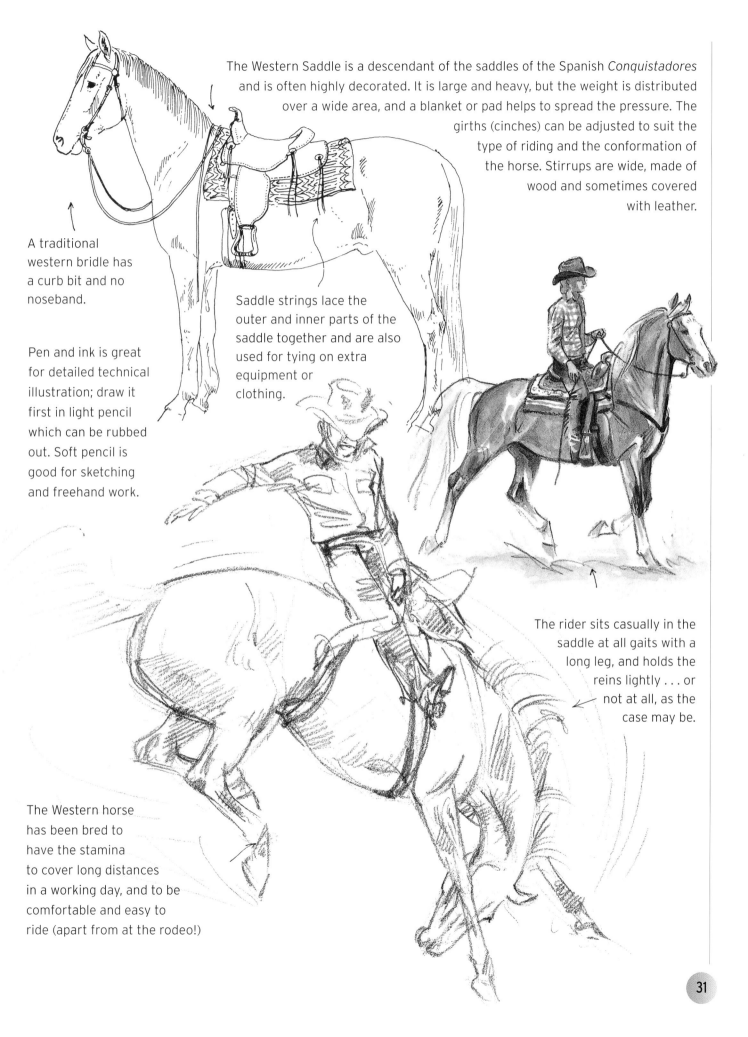

The Western Saddle is a descendant of the saddles of the Spanish *Conquistadores* and is often highly decorated. It is large and heavy, but the weight is distributed over a wide area, and a blanket or pad helps to spread the pressure. The girths (cinches) can be adjusted to suit the type of riding and the conformation of the horse. Stirrups are wide, made of wood and sometimes covered with leather.

A traditional western bridle has a curb bit and no noseband.

Pen and ink is great for detailed technical illustration; draw it first in light pencil which can be rubbed out. Soft pencil is good for sketching and freehand work.

Saddle strings lace the outer and inner parts of the saddle together and are also used for tying on extra equipment or clothing.

The rider sits casually in the saddle at all gaits with a long leg, and holds the reins lightly . . . or not at all, as the case may be.

The Western horse has been bred to have the stamina to cover long distances in a working day, and to be comfortable and easy to ride (apart from at the rodeo!)

31

14. HARNESS

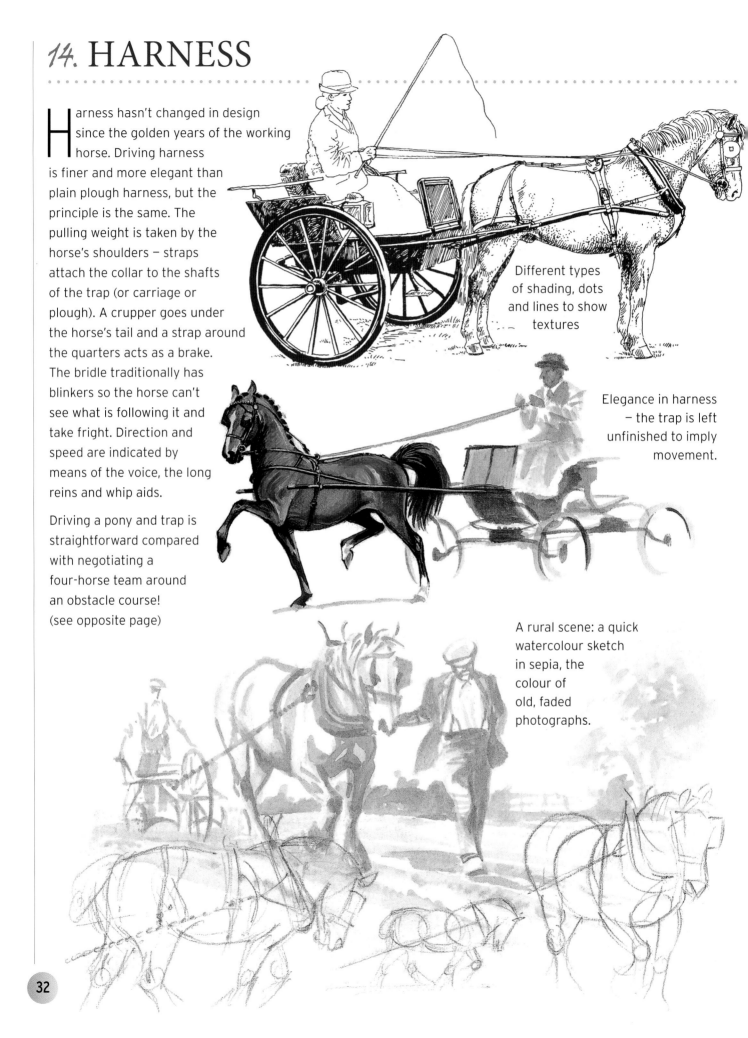

Harness hasn't changed in design since the golden years of the working horse. Driving harness is finer and more elegant than plain plough harness, but the principle is the same. The pulling weight is taken by the horse's shoulders – straps attach the collar to the shafts of the trap (or carriage or plough). A crupper goes under the horse's tail and a strap around the quarters acts as a brake. The bridle traditionally has blinkers so the horse can't see what is following it and take fright. Direction and speed are indicated by means of the voice, the long reins and whip aids.

Driving a pony and trap is straightforward compared with negotiating a four-horse team around an obstacle course! (see opposite page)

Different types of shading, dots and lines to show textures

Elegance in harness – the trap is left unfinished to imply movement.

A rural scene: a quick watercolour sketch in sepia, the colour of old, faded photographs.

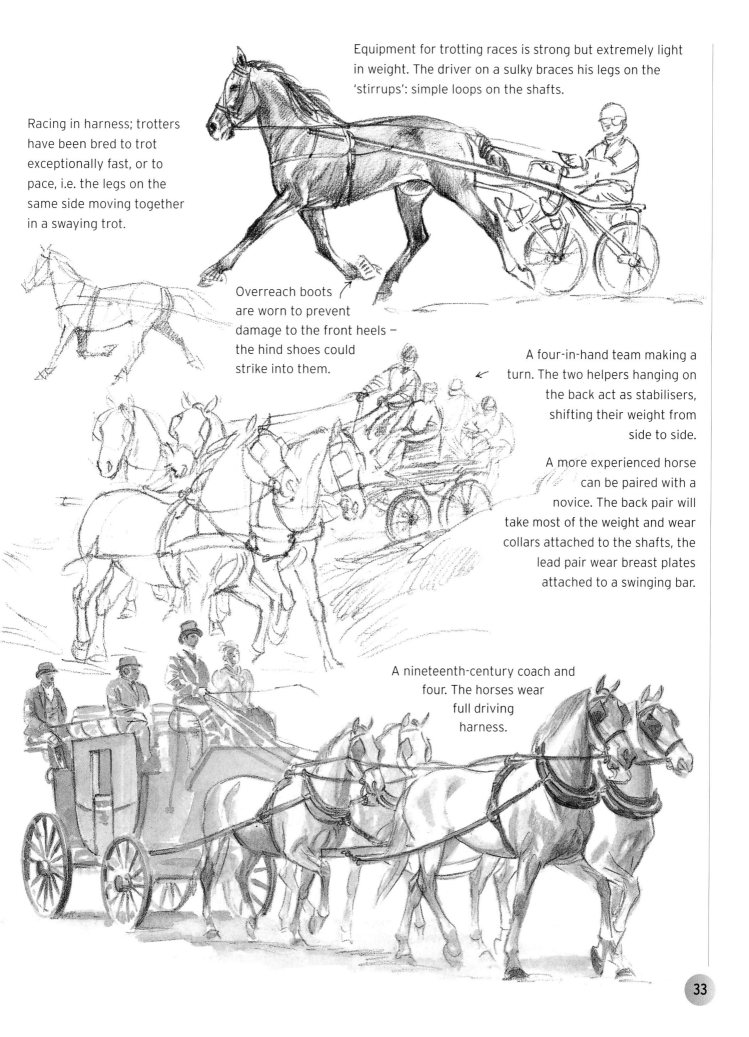

Equipment for trotting races is strong but extremely light in weight. The driver on a sulky braces his legs on the 'stirrups': simple loops on the shafts.

Racing in harness; trotters have been bred to trot exceptionally fast, or to pace, i.e. the legs on the same side moving together in a swaying trot.

Overreach boots are worn to prevent damage to the front heels – the hind shoes could strike into them.

A four-in-hand team making a turn. The two helpers hanging on the back act as stabilisers, shifting their weight from side to side.

A more experienced horse can be paired with a novice. The back pair will take most of the weight and wear collars attached to the shafts, the lead pair wear breast plates attached to a swinging bar.

A nineteenth-century coach and four. The horses wear full driving harness.

15. SPORTS

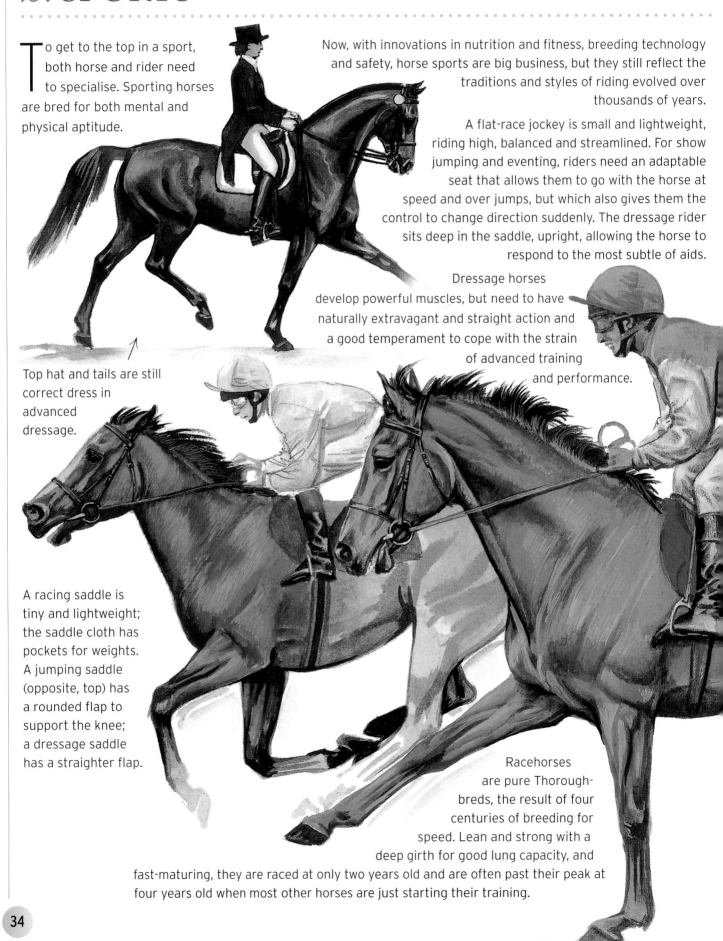

To get to the top in a sport, both horse and rider need to specialise. Sporting horses are bred for both mental and physical aptitude.

Now, with innovations in nutrition and fitness, breeding technology and safety, horse sports are big business, but they still reflect the traditions and styles of riding evolved over thousands of years.

A flat-race jockey is small and lightweight, riding high, balanced and streamlined. For show jumping and eventing, riders need an adaptable seat that allows them to go with the horse at speed and over jumps, but which also gives them the control to change direction suddenly. The dressage rider sits deep in the saddle, upright, allowing the horse to respond to the most subtle of aids.

Dressage horses develop powerful muscles, but need to have naturally extravagant and straight action and a good temperament to cope with the strain of advanced training and performance.

Top hat and tails are still correct dress in advanced dressage.

A racing saddle is tiny and lightweight; the saddle cloth has pockets for weights. A jumping saddle (opposite, top) has a rounded flap to support the knee; a dressage saddle has a straighter flap.

Racehorses are pure Thoroughbreds, the result of four centuries of breeding for speed. Lean and strong with a deep girth for good lung capacity, and fast-maturing, they are raced at only two years old and are often past their peak at four years old when most other horses are just starting their training.

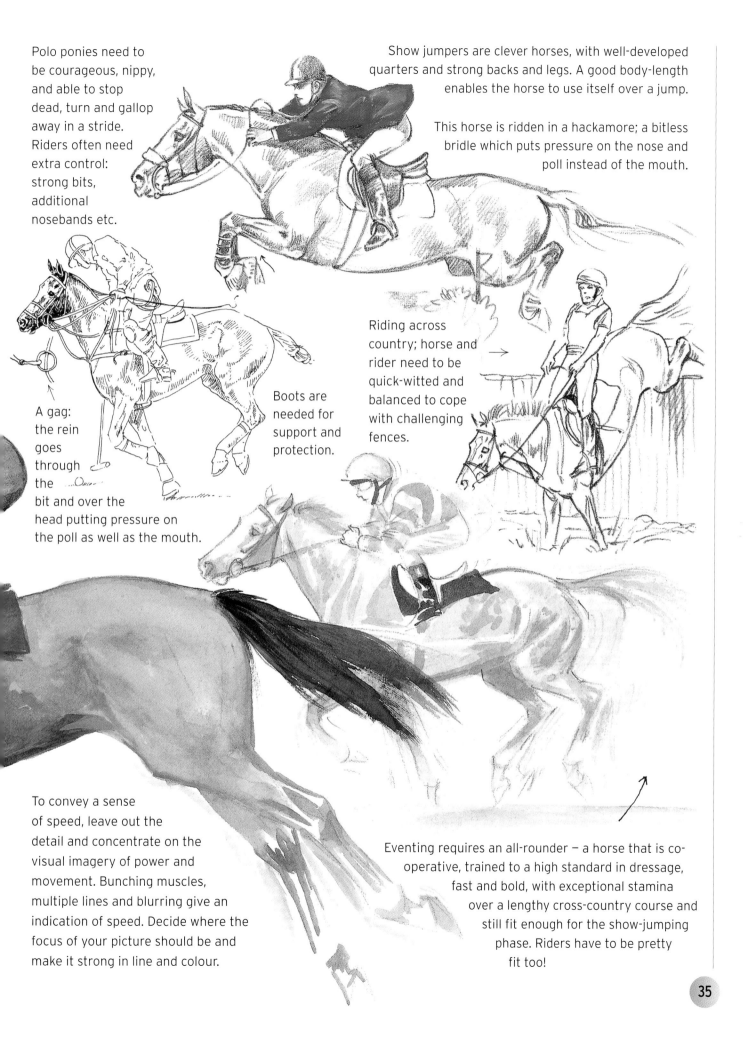

Polo ponies need to be courageous, nippy, and able to stop dead, turn and gallop away in a stride. Riders often need extra control: strong bits, additional nosebands etc.

Show jumpers are clever horses, with well-developed quarters and strong backs and legs. A good body-length enables the horse to use itself over a jump.

This horse is ridden in a hackamore; a bitless bridle which puts pressure on the nose and poll instead of the mouth.

A gag: the rein goes through the bit and over the head putting pressure on the poll as well as the mouth.

Boots are needed for support and protection.

Riding across country; horse and rider need to be quick-witted and balanced to cope with challenging fences.

To convey a sense of speed, leave out the detail and concentrate on the visual imagery of power and movement. Bunching muscles, multiple lines and blurring give an indication of speed. Decide where the focus of your picture should be and make it strong in line and colour.

Eventing requires an all-rounder – a horse that is co-operative, trained to a high standard in dressage, fast and bold, with exceptional stamina over a lengthy cross-country course and still fit enough for the show-jumping phase. Riders have to be pretty fit too!

16. BACKGROUNDS

Enjoy creating backgrounds. Put your horses in context and you'll make it a story rather than a study. Use your imagination as well as reference material: a quiet lane, the wilderness, a pastoral landscape, the romantic, the exciting, the weird and wonderful . . . A background needs to be central to your picture, not an afterthought. And it can work to your advantage; long grass or water can get you out of drawing hooves! If you enjoy drawing heads, a stable door makes a good frame. But don't duck a challenge. Only by doing new things (and practising things you find difficult) will you improve your skills.

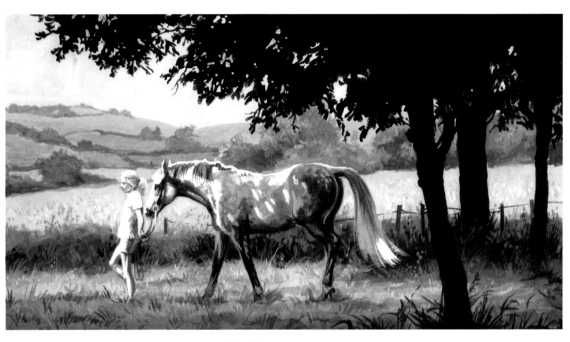

Drawing from life is more difficult than working from photos (which are already in 2-D.) It tests your skills and teaches you to *really* look at your subject. Don't expect to produce a finished work; horses don't stand still and you need to work fast. First, sketch lines that show bulk and movement, just an overall idea of shape, then add more detail *if* you have the opportunity.

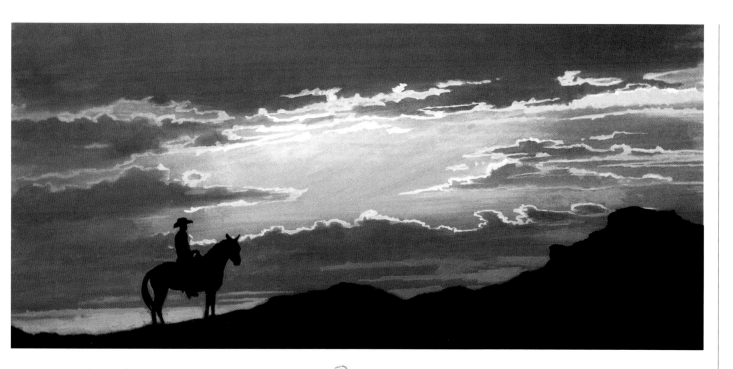

Out in the field, be aware of your own safety, horses can be unpredictable.

Stay near a fence or a gate and make sure someone knows where you are.

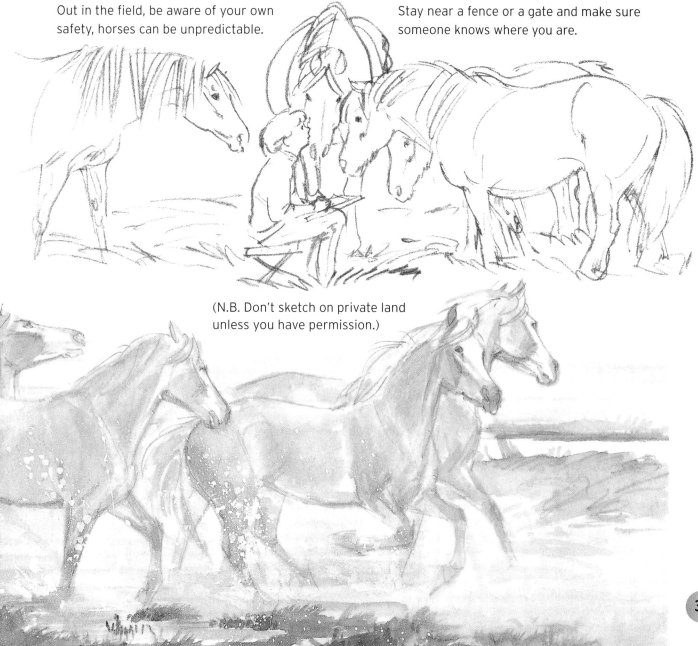

(N.B. Don't sketch on private land unless you have permission.)

17. BEHAVIOUR

Horses are neither machines that will do everything we ask, nor are they humans with four legs. They do not have *our* feelings and values; they are individuals with certain patterns of thinking and behaviour. They sense, and respond to, things that we would miss. They learn through repetition and the reinforcing of their basic instincts and abilities. They remember hurts for a very long time.

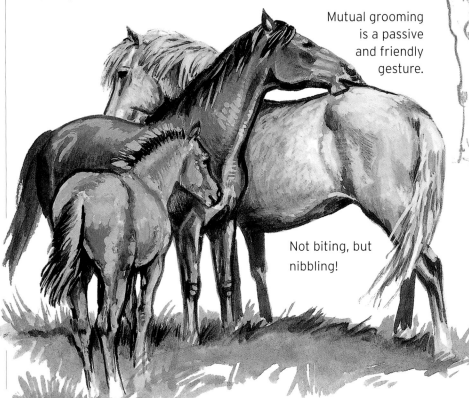

Mutual grooming is a passive and friendly gesture.

Not biting, but nibbling!

A bossy horse threatens a nervous horse. Even in a small group there will be a pecking order.

Horses communicate through their body language, and we can learn to understand a good deal of this if we spend time with them and watch them. The more we know about their natural behaviour, the more life and realism we can put into our drawings.

Frightened, aggressive, and threatening to bite or kick. Ears are laid flat back on the skull, eyes are open wide, showing their whites, nostrils are flared, skin twitches.

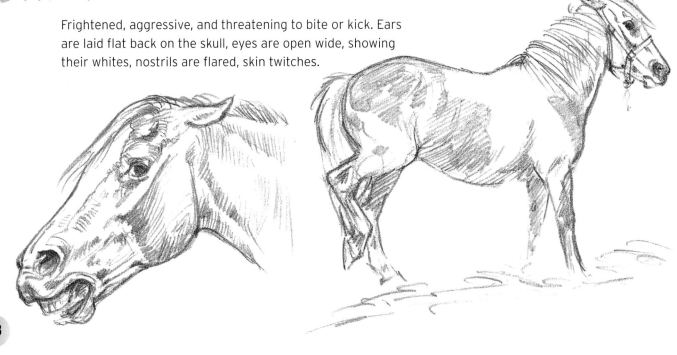

You cannot train a horse to do something which is totally unnatural to it.

Even *Haute Ecole* is a refinement of the natural movements, performed on command. Watch foals playing, prancing down the field in a spontaneous (if ungainly) passage –

or jumping around in an exuberant courbette.

Horses have very fast flight reactions, taking in the tiniest signals and sounds; their instinct is to be curious, alert, ready to run. Ears are flickering around, eyes darting from side to side trying to identify the source of any possible threat, muscles tensed for action.

Suddenly the lead horse can wheel round to run, the others turning to follow. In a safe field the horses will gallop off, bucking and kicking out for a short distance, but in the wild it could turn into a stampede.

It takes a great deal of training and balance to perform a movement that . . .

. . . seems natural to youngsters asserting themselves.

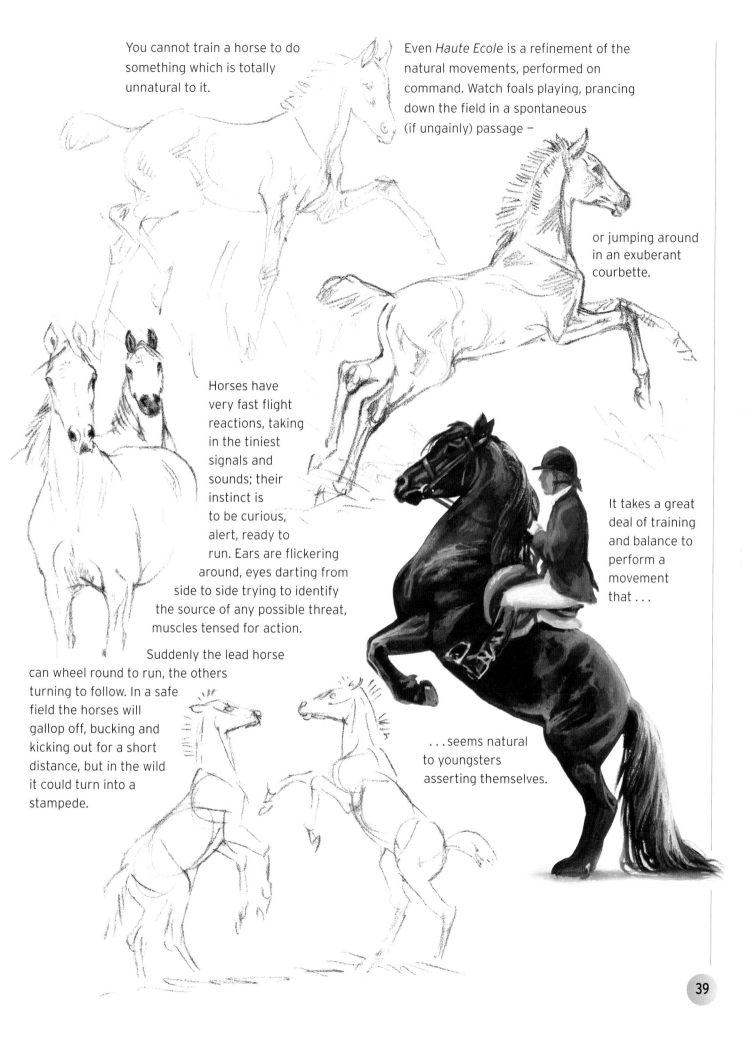

18. PORTRAITS

Some skill and experience is needed to paint accurately from life; portraits are *easier* to do from photographs, provided they are in focus, and the colour is right, with good light and shadow. Print it out to the size you want, or enlarge a photocopy, trace it and transfer the image to your paper or board. Pencil the underside of the trace then go over the outline again to leave an imprint, or enlarge it the traditional way: 'squared up'. Make a good trace of the reference you have, and draw a grid over the whole area, numbering them if you want to. Then, on your drawing paper or prepared board draw the grid again (in faint pencil so you can rub it out later) but **enlarge the squares**. Copy the traced image onto your larger grid, taking particular note of where lines intersect the grid, and the angles and shapes they make within each square.

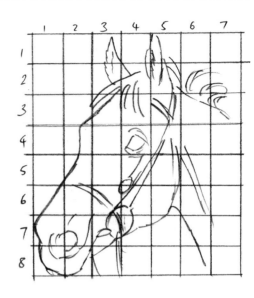

With digital technology it's fast and easy to find or create good references to work from.

NB If you're just painting for the love of it, and for practice, you can use printed sources as inspiration, but if you are exhibiting or selling a picture you have copied from someone else's photograph, you need the permission of the photographer.

This series of pictures shows how a watercolour study is built up; working from pale, transparent washes to more opaque details.

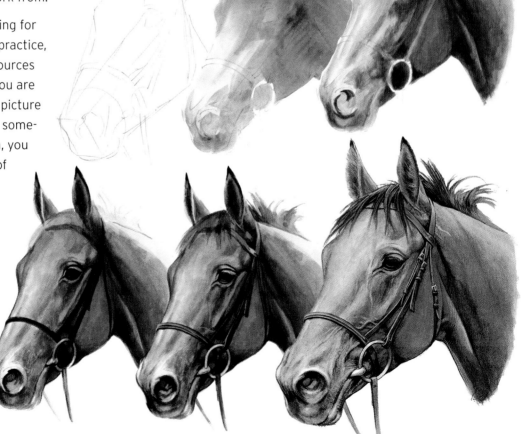

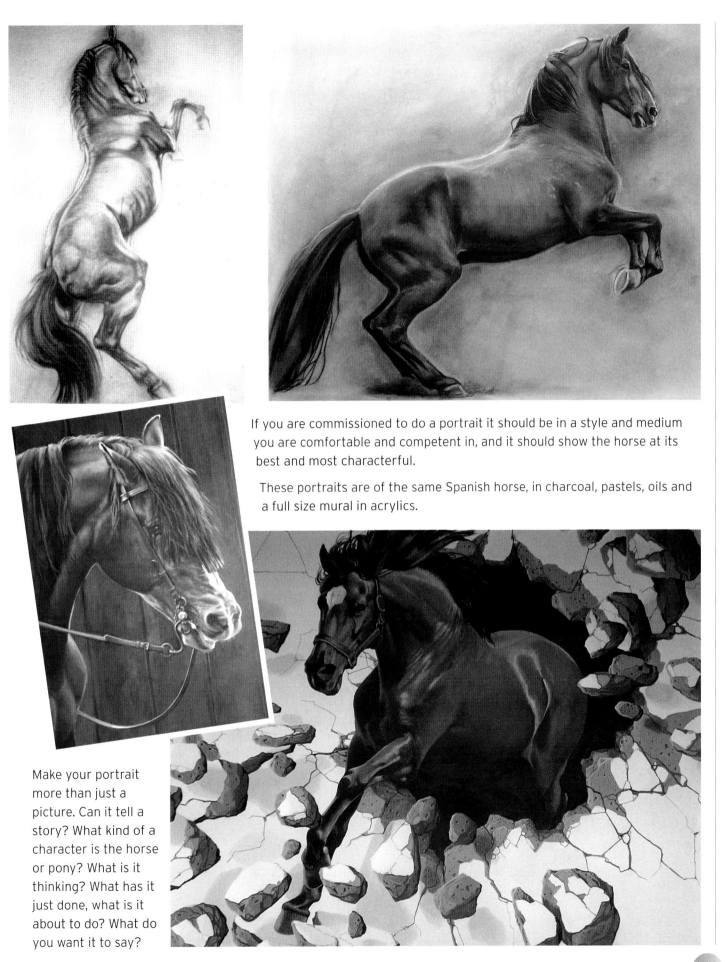

If you are commissioned to do a portrait it should be in a style and medium you are comfortable and competent in, and it should show the horse at its best and most characterful.

These portraits are of the same Spanish horse, in charcoal, pastels, oils and a full size mural in acrylics.

Make your portrait more than just a picture. Can it tell a story? What kind of a character is the horse or pony? What is it thinking? What has it just done, what is it about to do? What do you want it to say?

19. CARTOONS

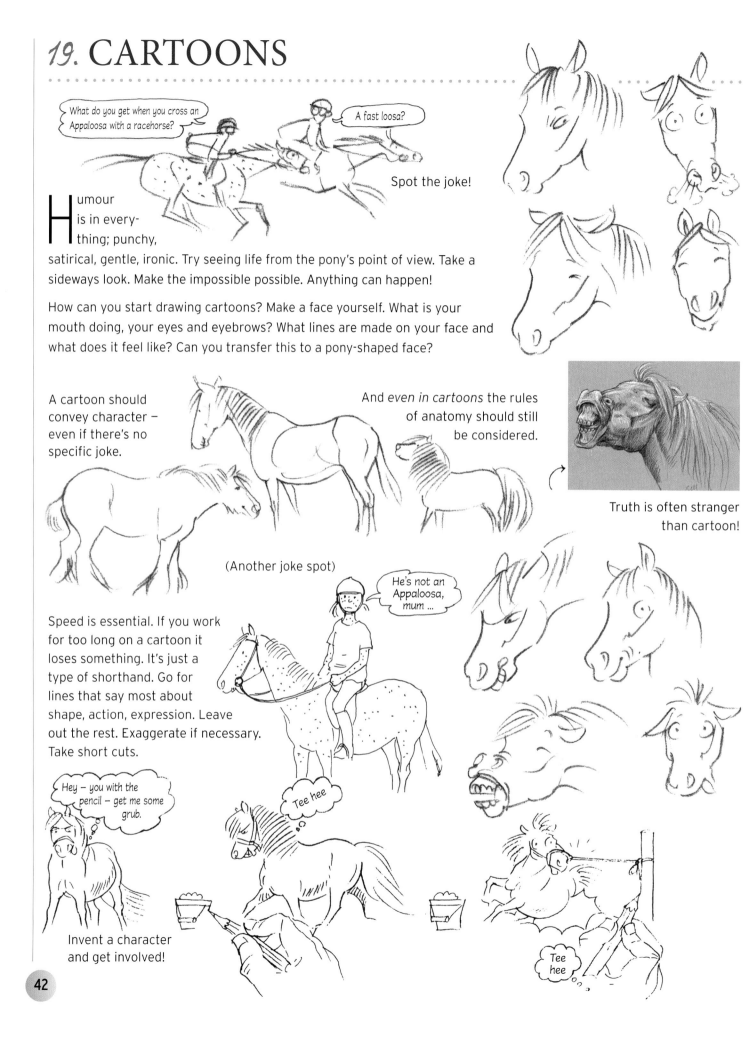

What do you get when you cross an Appaloosa with a racehorse?

A fast loosa?

Spot the joke!

Humour is in every-thing; punchy, satirical, gentle, ironic. Try seeing life from the pony's point of view. Take a sideways look. Make the impossible possible. Anything can happen!

How can you start drawing cartoons? Make a face yourself. What is your mouth doing, your eyes and eyebrows? What lines are made on your face and what does it feel like? Can you transfer this to a pony-shaped face?

A cartoon should convey character – even if there's no specific joke.

And *even in cartoons* the rules of anatomy should still be considered.

Truth is often stranger than cartoon!

(Another joke spot)

He's not an Appaloosa, mum ...

Speed is essential. If you work for too long on a cartoon it loses something. It's just a type of shorthand. Go for lines that say most about shape, action, expression. Leave out the rest. Exaggerate if necessary. Take short cuts.

Hey – you with the pencil – get me some grub.

Tee hee

Invent a character and get involved!

Tee hee

Cartoon strips take a bit of practice, but the more you do the easier it gets. There is a funny side to the simplest situation. Don't be influenced too much by other cartoonists. What makes *you* laugh?

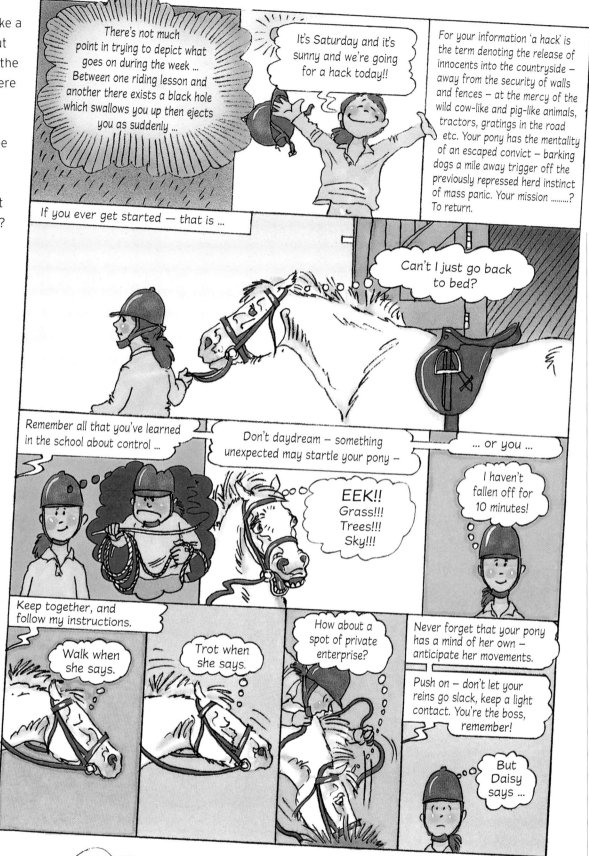

(Reprinted from 'Annie Learns to Ride' published by J. A. Allen & Co. Ltd. 1990)

20. FANTASY

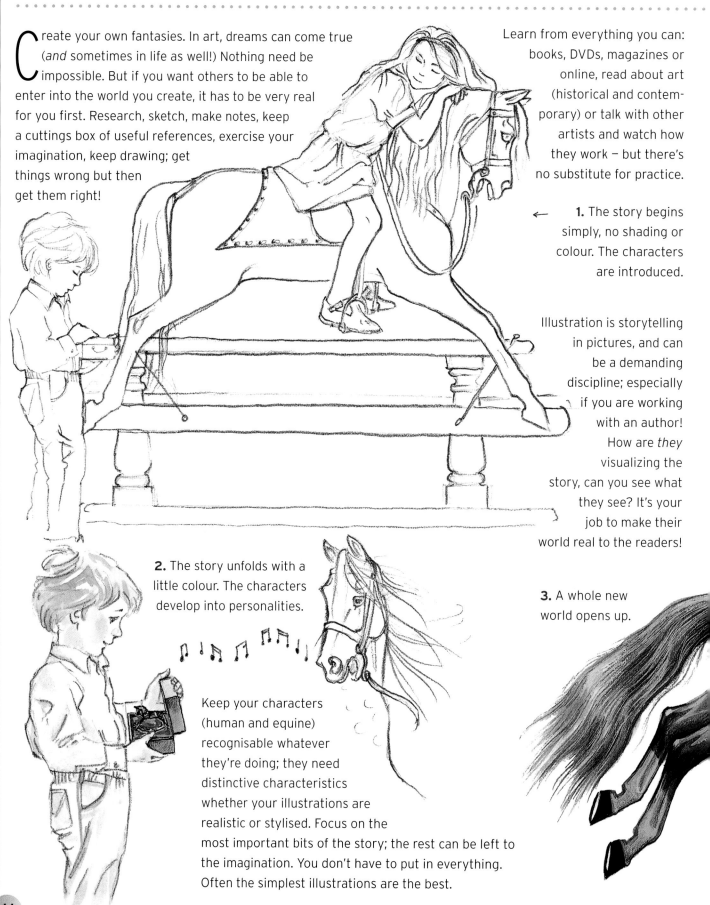

reate your own fantasies. In art, dreams can come true (*and* sometimes in life as well!) Nothing need be impossible. But if you want others to be able to enter into the world you create, it has to be very real for you first. Research, sketch, make notes, keep a cuttings box of useful references, exercise your imagination, keep drawing; get things wrong but then get them right!

Learn from everything you can: books, DVDs, magazines or online, read about art (historical and contemporary) or talk with other artists and watch how they work – but there's no substitute for practice.

1. The story begins simply, no shading or colour. The characters are introduced.

Illustration is storytelling in pictures, and can be a demanding discipline; especially if you are working with an author! How are *they* visualizing the story, can you see what they see? It's your job to make their world real to the readers!

2. The story unfolds with a little colour. The characters develop into personalities.

3. A whole new world opens up.

Keep your characters (human and equine) recognisable whatever they're doing; they need distinctive characteristics whether your illustrations are realistic or stylised. Focus on the most important bits of the story; the rest can be left to the imagination. You don't have to put in everything. Often the simplest illustrations are the best.

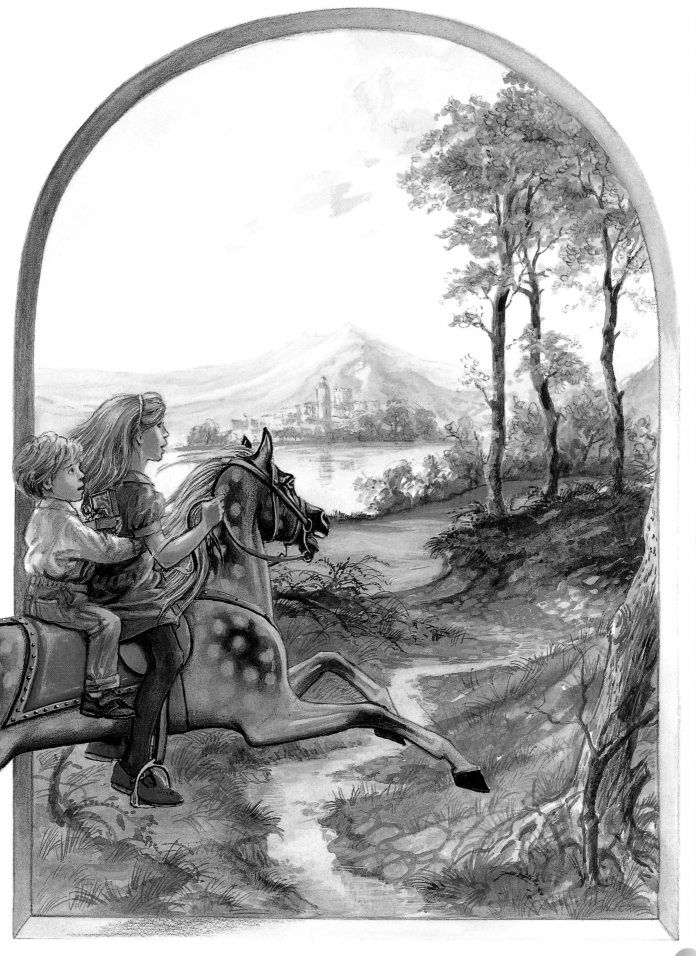

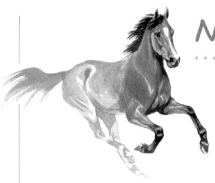

Notes and Sketches

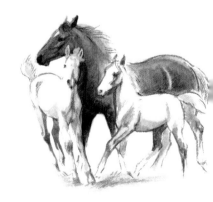

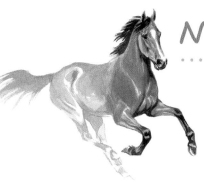

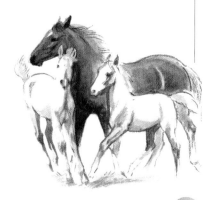